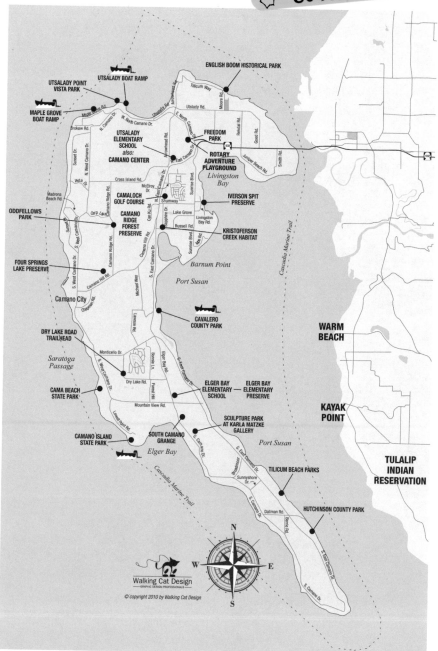

Camano Island map. *Courtesy of Walking Cat Design.*

Exploring
CAMANO ISLAND

A HISTORY & GUIDE

VAL SCHROEDER

Val Schroeder (signature)

Charleston ∣∣H∣∣ London
THE
History
PRESS

Published by The History Press
Charleston, SC 29403
www.historypress.net

Copyright © 2014 by Val Schroeder
All rights reserved

First published 2014

Manufactured in the United States

ISBN 978.1.62619.364.2

Library of Congress CIP data applied for.

To all the volunteers and willing landowners who made it possible to create, protect and restore these magical places—with special recognition to Carol Triplett, for connecting many of the people, groups and agencies.

And to the critters that let us share their island home.

Never doubt that a small group of thoughtful, committed citizens can change the world. Indeed it's the only thing that ever has.
—Margaret Mead, anthropologist

Contents

Contents

Preface

Shortly after I moved to Seattle, my parents came to visit, and we took a trip to Camano Island on a July day in 1985. My cousin hosted us at a barbecue at his place near the Utsalady Point Vista Park. While there, I crept down some rickety stairs and enjoyed strolling an empty beach. As it was summer, I probably shared it with some gulls and herons. I knew I was lucky to be able to enjoy a bit of waterfront living, but I had no idea how limited beach access really was for both island residents and visitors.

On that same trip, my parents and I continued down the island to visit Camano Island State Park. There we enjoyed the public beach and did some more strolling. Despite the sunny weekend day, the park beach was as peaceful as the private beach. Sharing the space didn't detract from our fine time lingering by the water.

Not long after that, I took another trip to Camano Island with a friend. Based on advice from a hiking book available for trips around Puget Sound, we decided to investigate English Boom. Unfortunately, we never left the car. What we came across was a "No Trespassing" sign. We drove around to other spots on the island and saw more of the same. Having previously had such a pleasant trip to the island, I have to say my impression did a major shift. I felt unwanted on Camano.

Being a water person, I was drawn to the beach communities and islands north of Seattle. In fact, I accepted a teaching job in the area, thinking this would get me closer to the water. It did; I moved to Camano. At the time

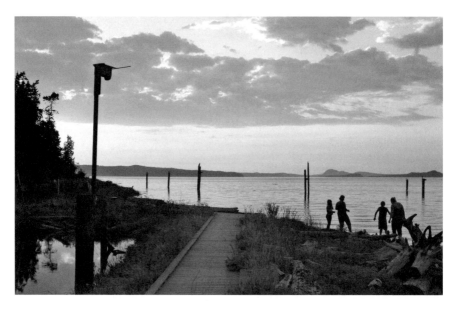

English Boom Historical Park, acquired in 1997, was the first public property on Camano Island purchased with Island County Conservation Futures funds. *Robert N. Cash.*

in 1994, besides a state park, there were only a handful of tiny public boat launches and pocket parks on the island.

Despite my previous misgivings about the community based on the numerous "No Trespassing" signs, I became a part of a community in action. Since I moved to Camano, there have been more than a dozen public nature preserves protected by community members with the help of nonprofit organizations. My impression of Camano changed when I was surrounded by so many people working together to preserve the island's natural areas.

I came at the perfect time. Besides the volunteer efforts to protect land and provide access to the forest and water, two tools made the process easier. In 1991, Island County adopted an ordinance based on the Washington State legislature allowing counties to create a Conservation Futures Fund to preserve lands of public interest for future generations. Island County began annually levying an amount that could not exceed six and one-quarter (6.25) cents per thousand dollars of assessed value in property taxes. The other tool offered a plan for action when Island County adopted its 1995 Non-Motorized Trails Plan.

With a plan suggesting possible trails on Camano and an Island County Conservation Futures Fund not yet used on the island, citizens had the

tools needed for action. Conservation Futures funds made it possible with little cost to us individual taxpayers to protect the natural treasures in the community because it could be used in collaboration with matching grants, private donations and countless hours of volunteer stewardship.

This book features the natural areas protected by the Camano Island community members. From a perspective of what the preserves offer islanders and visitors today, how they used them in the past and why the islanders protected them for the future, the book highlights the natural land, its history and the people wishing to live in harmony with nature.

Every day on Camano, I feel as fortunate and thrilled as I did the first time I strolled the beach using my cousin's waterfront access. Camano is a special spot. Part of it is because of its beauty and the wildlife that swims, soars and scampers in its waters, sky and land. Another part, and a huge part, is all the people who care so much about this island that they continue to protect it and keep us islanders sharing our space with the other creatures of the world.

Acknowledgements

This book is possible thanks to the volunteers, community groups and willing landowners who cared enough to protect the land for both wildlife and visitors. They all provided the material for this book. My goal from the start has always been to write this book as a tribute to their many hours of giving. I silently thank them every day on Camano when I watch eagles soar, notice seals following me, try to see the top of a towering Douglas fir or absorb whatever else stops me to witness nature at its best.

For crafting the book itself, I'm grateful that Aubrie Koenig, The History Press commissioning editor, approached the Whidbey Camano Land Trust for a possible book and that Elizabeth Guss, Whidbey Camano Land Trust development director, thought of me as the person to write the Camano story.

Thanks to Friends of Camano Island Parks (FOCIP) co-chairs Carol Triplett and Tom Eisenberg, I had access to 22.5 pounds of documents that explained how many of the preserves were protected on Camano. Having been involved during some of the acquisitions, I am humbled now realizing all the work that was completed behind the scenes.

I also am grateful to Washington State Parks staff Tina Dinzl-Pederson, Jeff Wheeler and Alicia Woods, who gave me access to photos and information. At the Stanwood Area Historical Society, I'm thankful to Karen Prasse and Bill Blandin, who provided photos and materials. I appreciate having the use of photos from Robert N. Cash, John Custer,

Tina Dinzl-Pederson and Tom Eisenberg, as well as the Camano map courtesy of Jim Shipley, Walking Cat Design.

I learned that fact-checking in a history book involves many rounds and sources. Many thanks go to several individuals who checked specific sections of the book: Helen Price Johnson, Island County commissioner; Ruth Milner, Washington Department of Fish and Wildlife biologist; Patricia Powell, Whidbey Camano Land Trust executive director; Carol Triplett, FOCIP co-chair; and Barbara Brock, Water Resources Advisory Committee member. Special thanks to Jim McDavid, Island County parks technician, who gave me a tour of the future Barnum Point Preserve.

To keep me from restating "trails," "parks" and "preserves" too many times, I'm thankful to the Hard-Nosed Zealots Writers Critique Group of Stanwood: Peggy Wendel, Mary Trimble, Lani Schonberg, Margo Peterson, Erika Madden, Gloria MacKay, Mary Ann Hayes and Darlene Dubay. Special thanks go to my first writing group members Len Smith and Jack Madison, who teach me about life and listen to whatever I write.

I am extremely grateful to my family. Thanks to Dave Baumchen's driving me around for photos and Barbara Schroeder's listening to my weekly deadline reports, I stayed on task.

I began writing this book thinking about the connections of the people who made it possible to protect wildlife habitat. After completing the book, I'm in awe of nature's connections in the ecosystem on, surrounding and beyond Camano Island. (Who would have thought a beaver pond could help juvenile salmon?) Here's to my bit of paradise in Puget Sound in the Salish Sea.

Introduction
Protecting Paradise

O nly an hour's drive north of Seattle, Camano Island has become a summer retreat for some and a bedroom community for others. The island itself has no town, but with a small bridge across Davis Slough to Leque Island and a larger bridge across the south and west passes of an old channel of the Stillaguamish River separating it from the mainland, Camano Island is accessible, and that's what's been part of its allure.

Camano Island is sheltered from the Strait of Juan de Fuca and the Pacific Ocean by Whidbey Island across Saratoga Passage to the west. With Skagit Bay to the north, Port Susan Bay to the east and Possession Sound to the south, Camano Island has fifty-two miles of shoreline in Puget Sound. The island shaped like a seahorse has a ridge about sixteen miles long from north to south and is one to seven miles wide, with the south end a narrow peninsula.

In a world surrounded by the loss of wild spaces, Camano Islanders love their Pacific Northwest paradise and don't sit around and fear for its future. Despite increasing development, islanders continue to unite to save the island's natural areas. Since 1994, more than a dozen nature preserves and parks have been protected through islanders working with one another and volunteer groups to preserve the land from future development.

Camano Islanders see their paradise as something worth protecting, and they've done it with the passion and gumption of both the citizens caring for the island and the citizens owning the land. Perhaps it all started in 1949, when Camano Island State Park literally became a state park in a day. With that "we-can-do-it" mindset, islanders still work to ensure their island thrives with

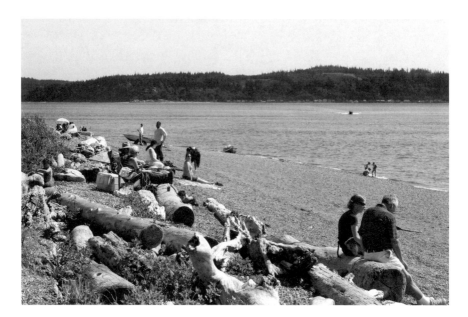

Camano Island State Park provides many choices of beach activities. *Washington State Parks collection.*

The National Wildlife Federation certified Camano as a Community Wildlife Habitat. More than eight hundred certified habitats provide the essentials for wildlife. *Author's collection.*

eagles, great blue herons, ducks and shorebirds living off the waters of Puget Sound or roosting in the cedars, hemlocks and Douglas firs on its shores. On an island not only without a town but also with few Island County services, Camano Islanders themselves have been able to unite to share space with the wildlife and keep a bit of the wild in the twenty-first century.

This has been possible with the leadership of volunteer groups, such as Friends of Camano Island Parks (FOCIP), Whidbey Camano Land Trust and Camano Action for a Rural Environment (CARE). These volunteer groups have united with landowners to preserve special spots on the island not only to preserve the land and link natural corridors but also to leave a legacy for the future.

Before 1994, aside from Camano Island State Park, there were only a few small parks on the island. Of the seven public spaces, six were pocket parks or boat launches. The prime initiator of preserving the land has been Friends of Camano Island Parks and its vision to implement the 1995 Island County Non-Motorized Trails Plan with the financial assistance of Conservation Futures funds.

The group originally formed in 1993 as Friends of Cama to promote the acquisition of the 433-acre Cama Beach Resort property. With the success of the state parks' acquisition in 1994, the group broadened its focus, changed its name to Friends of Camano Island Parks and provided volunteer services to all of Camano Island's county and state parks, as well as Department of Natural Resources (DNR) lands.

FOCIP has a clear mission that focuses on three elements of Camano Island parks: 1) acquisition of new parks and preserves to protect the habitat and forested lands on Camano Island; 2) education for all ages about the natural world; and 3) stewardship of the trails and parks on Camano Island, including construction of new trails and projects that will improve or enhance the parks. These three elements intertwine as the group seeks to not only acquire the natural areas but also maintain them so that they provide education, as well as enjoyment to the public.

In addition to its assistance in requesting Washington State Parks and the state legislature to purchase Cama Beach Resort, the group has sponsored projects by applying for Island County Conservation Futures funds dedicated to preserving habitat in the county. FOCIP has also worked with the Whidbey Camano Land Trust to preserve land on Camano. With the financial expertise of the land trust and the hands-on work of FOCIP volunteers, larger parcels of land have been protected.

Islanders have also benefited from the efforts of Camano Action for a Rural Environment. This group formed in 1997 to prevent the island gateway at

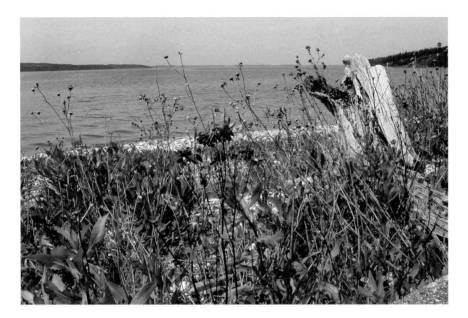

Enjoy purple columbine, driftwood and Saratoga Passage at Cama Beach State Park. *Washington State Parks collection.*

Terry's Corner from becoming a strip mall. The group's opposition led to Freedom Park, a park dedicated to the survivors of World War II.

With the perseverance of these volunteer groups, landowners were able to leave a legacy for the islanders and share space with the natural world. But that's not the end of preserving natural habitat; islanders have taken the idea to their own backyards. In 2005, the National Wildlife Federation certified Camano Island as a Community Wildlife Habitat. With more than eight hundred properties on the island certified as wildlife habitats that provide food, water, shelter and space, as well as use responsible gardening practices, individual yards and parcels link together with the parks and preserves to restore natural corridors. The Camano Wildlife Habitat Project started with a simple vision for the island: to create an island in harmony with nature—one yard at a time.

An island in harmony with nature is a vision that islanders continue to take to heart as they work together to restore and protect the natural wonders of the island. With the island's transitions from wilderness to Native American camps, to logging camps, to farms, to resorts, to second homes, to developments, some areas still provide the Pacific Northwest paradise islanders sought when choosing to live on an island surrounded by Puget Sound and the rivers flowing into the sea.

Camano Island through the Ages

Beginning as a remnant of the ice masses moving south from Canada during the Vashon Glaciation, Camano Island emerged from the scouring and weight of the glaciers when the ice receded ten to twelve thousand years ago. Water from the melting ice shifted sand, gravel and clay, and as this sediment settled, the pounding waves of the sea eventually formed the glacial moraine into Camano Island. Within these sediments lay remains of peat from previous life in between the glacial periods, and that provided the spark for the island's forests to begin growing.

Eventually, forests of Douglas fir along with western hemlocks and western red cedars became the dominant trees on the island, with alder and maple near stream banks, flood plains and shorelines. These trees flourished in the Pacific Northwest's mild climate. Nurse logs decayed and created ideal conditions for the coniferous forest.

Mountains shaped the island's climate, with the Cascade Mountains to the east protecting it from extremes and the Olympic Mountains creating an obstacle from the Pacific Ocean's precipitation by creating a rain shadow for the island. Before the loggers arrived, the island was primarily forest. In the understory beneath the massive trees grew sword fern, salal, salmonberries and thimbleberries. With food, water and space readily available, elk, deer, beavers, eagles, otters and even cougars and black bears thrived. On the beach, mussels and clams provided for the mammals and birds, while farther out into the bays, salmon and harbor seals swam.

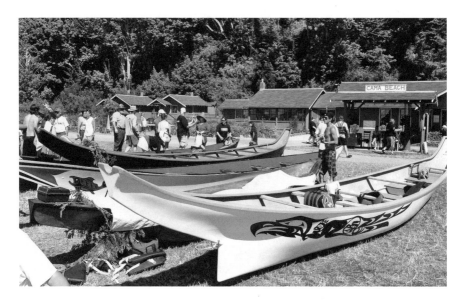

The Canoe Journey celebrates the Northwest tribal tradition of summer gathering. Tribes camp at traditional sites, which include Cama Beach State Park. *Tina Dinzl-Pederson.*

Although current archaeological evidence indicates humans lived on the island six thousand years ago, the Coast Salish, the most prominent Puget Sound Native American cultural group, arrived on Camano Island by AD 1300, probably from the mainland via the rivers. The Kikiallus, one group of the Coast Salish people, had villages on the north and west of the island with access to the Skagit River and delta, while the Snohomish had south end villages with access to the Snohomish River and delta. The Coast Salish occupied most of the sites as summer camping grounds for fishing, hunting and berry or root gathering.

They also had permanent villages with cedar longhouses that several families shared. The Salish placed the permanent villages in sheltered island waters with abundant fish and shellfish. Before the arrival of the white settlers, the land had not been altered much from its original state. However, besides the Native American camps and villages, an abundance of plants that the Salish preferred and frequently used, especially bracken, camas and nettles, would have been found. This resulted partially because the plants preferred the soil conditions the humans had altered, and later after becoming used to the plants, the Salish cultivated the land to promote growth for these plants as staples. The Salish also used fire to shape the forests and the animal populations. Clearing the land with fire enhanced

deer and elk habitat. This not only assisted the Salish's hunting but also influenced the predator wolf population.

Richard White writes in *Land Use, Environment, and Social Change: The Shaping of Island County, Washington*:

> *Changes such as these were not readily apparent to the casual observer. Unless the environment bore obvious marks of human handiwork, the first whites dismissed it as wilderness, natural and untouched. But wilderness has little meaning when applied to Island County and areas like it. This was a land shaped by its inhabitants to fit their own purposes. They populated this land with spirits and powers, but they did not restrict their manipulation to magic. Through observation and tradition, Indians altered natural communities to fit their needs without, in the process, destroying the ability of those communities to sustain the cultures that had created them.*

Exploratory voyages by the Spanish, British and Americans between 1790 and 1847 recorded Camano Island on the charts. In 1847, British navy captain Charles Kellet on the surveying vessel *Herald* named the island Camano to recognize Jacinto Caamaño's explorations. This replaced the local Coast Salish name, *Kol-lut-chen*, which means "land-jutting-out-into-a-bay." Eight years later, on January 22, 1855, the Kikiallus chief, Sd-zo-mahtl, signed the Point Elliot Treaty, which ceded their land to the white settlers in return for promises. It also diminished the Native American presence on Camano Island.

The Native Americans who remained on the island assisted white settlers at the logging camps and the mill at Utsalady on the north end. United States government land provided the timber source when, in 1861, the territorial legislature authorized locating and selling public lands. Throughout the 1860s to 1890s, lumber prices fluctuated, and the Utsalady mill closed in 1891. Demand for logs returned around 1900, and ten to twenty logging camps operated throughout the island into the 1920s. After first removing Douglas fir from the island, western red cedar's value surged, and five shingle mills began operating on Camano.

With the lumber, shipbuilding and fishing industries thriving, Utsalady became a port. The Royal and United States Mail and Carrier Lines, the transatlantic Inman Line and the United States Office of Registration for seagoing vessels opened offices. Utsalady had a store, post office, blacksmith shop, saloon, bunkhouse, recreation hall and hotels. The steamer *Edna* made trips to Coupeville on Whidbey Island twice a day, except Sundays. The

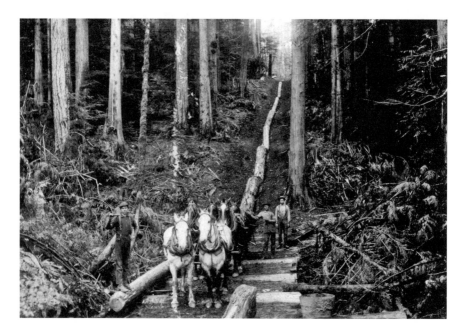

A logging train on a skid road, perhaps Tom Esary's Camano crew near the future Cama Beach Resort. *Amy Whitmarsh Collection. Stanwood Area Historical Society 2008.30.05 circa 1909.*

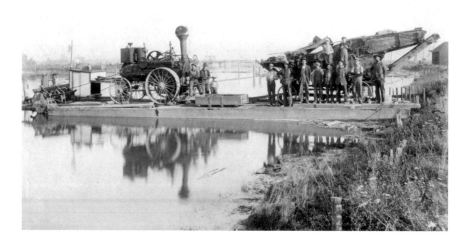

A threshing machine and tractor on a barge between Stanwood and Camano. The owner of the threshing machine traveled between farms to harvest. *Stanwood Area Historical Society 94.105.08.*

Acorn made trips from Oak Harbor to Utsalady from 1925 to 1935. Ferry service was eliminated with the completion of the Deception Pass Bridge from Whidbey Island, which provided access to Fidalgo Island and the mainland. (Today, Utsalady is a beach community with no stores or hotels, just homes, and definitely no ferry service between the islands.)

Logging and clearing the island left massive piles of debris. Loggers assumed the forests to be an endless supply. However, the stumps, logs and limbs left on the ground hindered the forest's natural progression and increased the danger of fire, which killed seedlings and altered the composition of the forest. Much of the forested land was eliminated by the 1920s, and by 1938, the National Land Planning Board treated Island County as an unforested area in future planning.

Once the logging era completely cleared Camano Island, landowners promoted farming and even second homes. However, these potential farms and homes would require plenty of work. Removing the slash and stumps of old-growth forests of Douglas fir, western red cedar and western hemlock was no easy task. To make things worse, after the work, most of the land had poor soil. Nevertheless, farmers began to occupy the island. Cows and goats grazing the grass growing between the stumps of the island provided the cream, milk and cheese for Stanwood citizens on the mainland. Later, growing successes came from oats and strawberries.

Along the shoreline, recreation evolved. During the logging boom days, locals and vacationers enjoyed campsites and summer cabins at Utsalady and Rocky Point. Recreational cabins and camping opportunities multiplied throughout the island as cars became more popular and available. Eventually, some people bought lots for cabins; others bought acreage for resorts. Eddie Bauer's 1937 Fishing Directory had a map of the Saratoga Passage area showing five resorts on the west side of the island. The advertisements for the resorts stressed the island's accessibility without a ferry.

The resorts at the time served a need. City dwellers could enjoy the country life by using the resorts and their amenities without ownership hassles. Vacationers could have seashore living and even go fishing on Puget Sound without owning a boat. With the rebirth of the vegetation and natural features of Camano after the logging years, fishermen and hunters left the city for salmon, deer, quail and pheasant.

Unfortunately, the wildlife populations suffered from intense pressure from these enthusiastic sportsmen. While deer were abundant because of the cleared habitat, the introduced quail and pheasant from the nineteenth century needed restocking. Loss of wetlands, along with the hunting, contributed to the decline in waterfowl. Predatory birds also suffered for

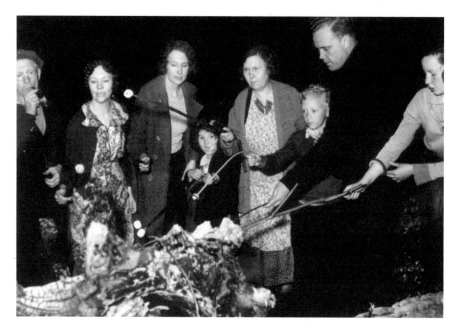

A family marshmallow roast at the beach, 1936 Camano Island. *Courtesy of Washington State Parks and Recreation Commission, Worthington and Hamalainen Collection, ID# 201.2008.2.58.*

killing game birds. Island County sportsmen's organizations provided bounties on hawks and owls.

Recreational fishing and commercial fishing began to clash. Resort owners needed their customers to catch fish, and an initiative to ban fish traps and wheels passed statewide in 1934. Later, in 1941, sportsmen and conservationists applied pressure to close clam and oyster beds for commercial use on the island's shoreline. With the city dwellers visiting the island paradise for relaxation or sport, the plants and animals they liked would be protected, such as shellfish and salmon, but those they found disagreeable would be eliminated, such as hawks, crows and wetlands.

Richard White writes:

> *Even with human aid, most native wildlife seemed precarious visitors in a world where they had once seemed permanent fixtures. The only fauna that seemed to thrive in the county, totally impervious to human wishes and designs, were the rabbit and man's old traveling companion, the rat. Only the invaders were secure on the islands; the natives had just obtained a reprieve.*

Left: A brochure produced by members of commercial clubs of East Stanwood, Stanwood and Camano Island, circa 1955. *Cama Beach Resort Photograph Collection; Stanwood Area Historical Society.*

Below: Before public access became more available, signs like these were a frequent sight on Camano Island. *Author's collection.*

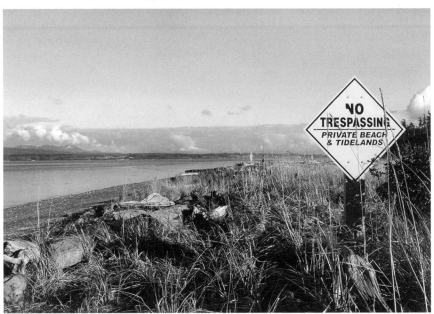

The decline in game and fish resources resulted in fewer guests, and resort owners began to have a more difficult time retaining seasonal visitors. As the resorts closed, the owners divided and sold their land. Much of the land sold became cabins for previous resort vacationers. With few businesses on Camano Island, people living on the island either commuted to jobs off the island, retired or had second homes and came for the summer. Real estate and development became the industry on the island, and property taxes became a main funding source for Island County.

Even though some of the forests eventually returned to Camano Island, once again they were being cleared and hauled away, only this time more quickly with chainsaws and logging trucks. However, not everyone wanted the island's rural environment destroyed. Islanders began working together to safeguard why they moved to the island—big trees, clean water and wildlife roaming, flying and swimming. Because these islanders united their efforts and resources, Camano Island has special places that will continue to flourish naturally not just now but for the future of all the island's inhabitants—those with arms, paws, wings and fins.

Camano Island State Park

1949

TODAY

Camano Island State Park, on the southwest portion of the island, offers a niche for outdoor enthusiasts, with access to the beach being a prime motivator for many visitors. The 173-acre park has two boat ramps and 6,700 feet of Puget Sound beachfront on Saratoga Passage. Across the passage is Whidbey Island, and visible in the distance are the peaks of the Olympic Mountains and Mount Rainier to the southeast in the Cascade Mountains.

With the North Beach and South Beach areas at the park, it's easy for visitors to choose the type of experience desired. The South Beach may be the largest draw for visitors with its boat ramps, picnic shelter, expansive beach filled with shells and driftwood and open space for picnic tables. There's a fair amount of parking, so it's easy to choose which end of the beach fits a visitor's activity—picnicking, swimming, fishing, boating, bird-watching, beachcombing and hiking. The boat ramp area to the north provides parking for trailers and also a hut for borrowing life jackets. The south end has a kayak campsite that's on the Cascadia Marine Trail for kayakers or other non-motorized boaters traveling Puget Sound. The middle section has the picnic shelter, which volunteers helped to build, and restrooms. Picnic tables are scattered throughout the open areas between the boat launches and the kayaking campsite.

Tucked away behind the parking area across from the picnic shelter is a marsh hidden by cattails. Friends of Camano Island Parks created a trail along the bluff side that allows visitors a chance to peek at the wetland plants and ducks. In the spring, there's an opportunity to hear a concert when the frogs begin their seasonal croaking. This marshland trail also connects with the canyon trail that takes visitors into the second-growth forest that has grown after the logging days that cleared the island.

A five-mile trail system throughout the park, developed and maintained by the volunteers of Friends of Camano Island Parks, provides a Perimeter Loop Trail along the bluffs with outstanding views through the forest to the water. Trails in between the loop trail connect to the campsites, group camp, amphitheater and beach areas. Starting at the South Beach Lowell Point parking lot, follow the Marsh Trail before climbing many stairs to the West Rim Trail, which provides stunning views of Saratoga Passage and the Olympic Mountains. Continuing across the road, the trail passes through an old-growth area and fern grotto before reaching the South Rim Trail with views of Elger Bay and the Cascade Mountains. Crossing the road again, the trail travels through the campground before reaching the Canyon Trail between campsites #3 and #4. The Canyon Trail is another series of stairs through a ravine lush with sword ferns. The canyon watershed enters the marsh, where nature does its protecting and cleaning of the waters.

Signposts provide directions through the various trails, and maps are available at the ranger office. By following the West Rim Trail, visitors can hike to the North Beach picnic area and beach. There is also a parking area for the North Beach area. The North Beach requires walking the stairs or trail down, but it is a quieter spot. With picnic tables and a picnic shelter above, the beach offers opportunities for beach combing, rock skipping, wading and resting on many driftwood logs. The picnic area also has a historical kiosk that honors the community effort that shaped the park and ensured public access to beaches on Camano Island.

Since the park was created in 1949, the Douglas fir, western hemlock and western red cedar have stretched to the skies, and hikers must stop and lift their chins to try to get a full look at the treetops providing shade for the sword ferns to flourish, as well as salal, Oregon grape, salmonberry, red flowering currant and other native plants of the Pacific Northwest. The Al Emerson Nature Trail, named after the park's first ranger, has signage and an interpretive booklet to help visitors recognize the various native plants and the history that occurred along this half-mile trail. Among the understory, evidence of the old-growth forest can be seen on the stumps with notches

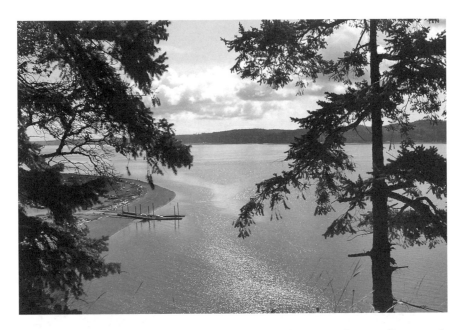

Camano Island State Park's West Rim Trail overlooks the boat ramp, Saratoga Passage and Whidbey Island. *Author's collection.*

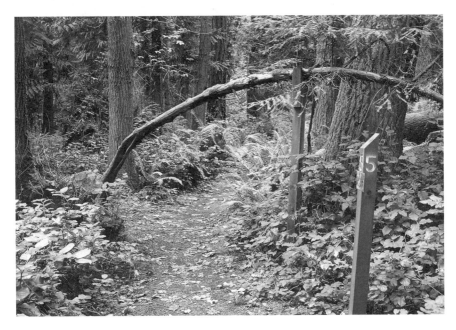

The Al Emerson Nature Trail at Camano Island State Park is a half-mile loop interpretive trail with identification signs and a trail booklet. *Author's collection.*

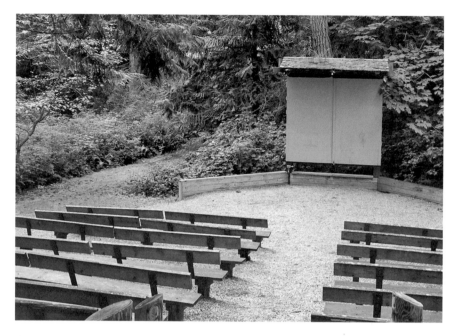

Camano Island State Park has Saturday night summer interpretive programs between Memorial Day and Labor Day at the amphitheater. *Washington State Parks collection.*

that the loggers cut to place springboards and stand above the swollen tree's base with their crosscut saws for felling the trees.

The park offers both camping and cabin overnight choices. The individual and group campsites with fire grates and picnic tables are located above the beach in the forest and include a few campsites with views of Saratoga Passage, the Olympic Mountains and Whidbey Island. Utility campsites are not available. The park also has five cabins that provide a bunk, table and chairs, a picnic table and easy access to trails. One of the cabins is even pet friendly. Water and restrooms with showers are close to both the campsites and cabins. The park is open year-round and is a first-come, first-served campground with no reservations required.

During the summer between Memorial Day and Labor Day, Saturday evening interpretive programs provide both education and entertainment. Sometimes the programs include a field trip for more immediate opportunities to learn about such things as plants, stars or geocaching. An annual or one-day Discover Pass is required.

YESTERDAY

Just imagine building this state park in one day.

Not possible? Well, think again.

That's how the community created Camano Island State Park sixty-five years ago.

Several local citizens remember that grueling day, July 27, 1949, when they joined with more than five hundred community volunteers and organized themselves into a slick human dynamo that bulldozed, chopped, sawed and raked. When it was over, they had converted ninety-two acres of publicly owned school land on Elger Bay into a public recreation area.

"In one of the most magnificent volunteer efforts seen in Puget Sound country, the park's original ninety-two acres were transformed into a new public area," said Patricia Nash, former Friends of Camano Island Parks naturalist. "What a thrilling sight it must have been."

A second goal motivated these volunteers. The South Camano Grange entered its state project in a national grange community service competition. They hoped to win first prize, which would mean $12,000 to update the grange hall.

The mayors of the twin cities of Stanwood and East Stanwood declared Wednesday, July 27, 1949, Camano Island Park Day. A full-page advertisement appeared in the newspaper seeking "500 Public Spirited Workers."

Prior to Camano Island Park Day and after the South Camano Grange petitioned the Washington State Parks Commission, the state set aside the land and asked that volunteers create the park. The State Park Board also provided $5,000, in addition to surveying and marking sites for buildings, roads and pathways.

As Camano Island Park Day dawned, a caravan of vehicles and buses transported men, women and children along with their spades, hoes, rakes and saws to the site in the current North Beach area. Others were organized into work groups. Locations for trails, roads, campsites, picnic spots and parking areas were cleared and leveled. Workers constructed buildings and cleared a spring for a water source. Bulldozers made a road along the bluff to the beach. Equipment included three bulldozers, nine farm tractors, thirty-four pickups and trucks, one large trailer truck, three wreckers and a team of horses. Sam Clarke, director of state parks, supervised a crew of engineers and technicians from Olympia as well as the local volunteers.

To ensure worker safety, a doctor and nurse staffed a first-aid station. Grange women served fifty gallons of chowder. Young helpers received

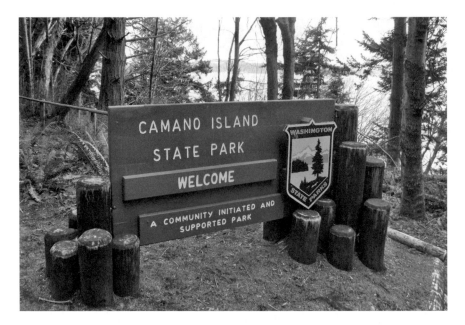

The Camano Island State Park welcome sign recognizes volunteer efforts that created the park and continue to support park projects. *Washington State Parks collection.*

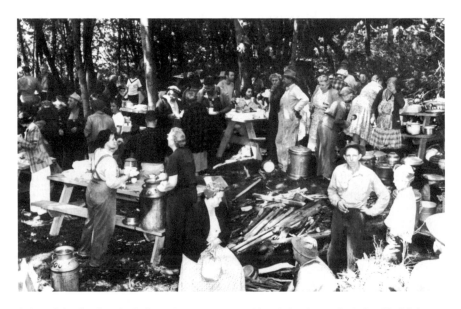

A few of the five-hundred-plus volunteers prepared lunch for those who helped build the state park in one day. *South Camano Grange, circa 1949.*

soda pop as a reward. By the end of the day, even the picnic tables were ready. The day's donation of 3,561 volunteer hours, 376 machine hours and all expenses had an estimated value of $6,000. The entire project included 12,552 volunteer hours and 1,551 machine hours, with most expenses donated.

Despite the community effort that practically put businesses in Stanwood and East Stanwood at a standstill for the day, the South Camano Grange didn't win the coveted prize. Instead, it tied for third place with a South Carolina grange and won $1,000. However, the community gained Camano Island State Park. The project became a benchmark for public participation in park development.

The South Camano Grange used the National Grange Community Service Contest as an action step to enhance Camano Island, as the group explained in its contest introduction:

> South Camano Grange is located on Camano Island, a small island between Whidbey Island, several times as large, and the mainland. Across a primitive bridge are its marketing centers, Stanwood and East Stanwood, in Snohomish County.
>
> It has approximately 925 registered voters, mostly retired people, farmers and fishermen.
>
> Camano and Whidbey Islands form Island County. To reach Coupeville, the county seat on Whidbey, Camano residents must drive 100 to 140 miles, round trip, through Snohomish and Skagit counties.
>
> County activities and government have always centered on Whidbey, and county offices have been filled by members of a certain few families living there. One county commissioner is customarily elected from Camano, our only voice in county affairs.
>
> Because of these facts, and of infrequent contacts, county officials have had little knowledge of our conditions or interest in them, and because no organized effort has been made to present our problems or secure action correcting them, bad situations have become and remained chronic.
>
> These were so numerous that South Camano Grange established a Planning Committee to study the needs of Camano Island and take every possible step to alleviate them. We entered the National Community Service Contest partly because it seemed a good focusing point for our problems and our efforts, a means of solving our problems and of unifying our community for better understanding and a better life for all of us.

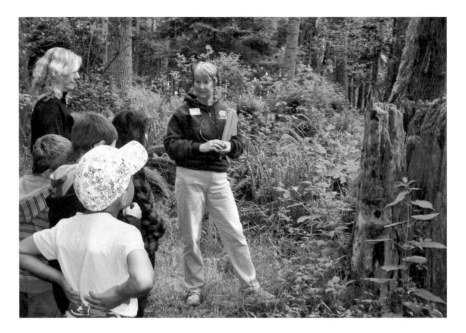

Pam Fredericksen, a FOCIP volunteer, teaches area second graders about stumps during the annual state park forest and beach education day. *Washington State Parks collection.*

Interestingly, these same feelings of isolation from Whidbey Island and the county operations continue today. In the project description, the Grange also stated, "Our entire shoreline was owned by individuals, resorts, or real estate or lumber companies, except ninety feet in three different points owned by the County, these not generally known. The general public had no access to the beach."

In 1958, the state bought the Lowell Point property from the Chief Seattle Land Company. This added an additional 80.5 acres to Camano Island State Park, including three thousand feet of additional waterfront public access.

After Friends of Cama changed its name and focus and became Friends of Camano Island Parks (FOCIP) in 1994, FOCIP expanded the trail system at the state park. The perimeter loop connected the short existing trails. A trail was built to the park entrance and eventually continued as a connector trail to Cama Beach State Park. FOCIP also restored the amphitheater and began hosting Saturday night interpretive programs for campers and area residents during the summer. FOCIP continues to take an active role organizing the interpretive programs, hosting hikes and providing education days for local schoolchildren, besides maintaining the trails.

LEGACY

With a look to the future, Washington State faces the challenge of supporting the state parks with a smaller amount of tax dollar support. The ten-dollar-a-day or thirty-dollar annual Discover Pass has been added in recent years to help pay for parks, but that is not bringing in the funding initially anticipated. It also may be a deterrent to some who cannot afford the fee. The economic aspect is a reality, and the state park administrators and state legislators continue to look for ways to maintain the parks, as well as keep them in the state park system.

Part of the success of the state parks is the community partnerships. In 2012, more than 224,000 volunteer hours equated to more than $3 million worth of labor statewide. Besides the "free labor," the input of state parks' visitors spending in the local economy generated $34 million in state taxes, with Camano Island's two state parks being the largest driver in Camano industry and contributing $40 million to the tenth legislative district, according to Jeff Wheeler, Cama Beach Area State Parks manager.

Looking beyond the economics, a comprehensive view examines what the state parks do for the visitors. Parks become the special places where people continue to go, according to Wheeler. They provide the memories and the reconnections.

Moving ahead for Camano Island State Park, the Washington State Parks and Recreation Commission took public comments about a future plan for the park. This plan mentions the potential for habitat enhancement, particularly for salmon recovery. In 2011, the Skagit River System Cooperative proposed salmon habitat restoration for an area that might have once been a spit and lagoon, which would have provided ideal conditions for juvenile salmon acclimating to the salt water after leaving the freshwater rivers. The island at one time had several of these salmon nurseries, but shoreline development has destroyed most of them. Camano Island State Park has the potential to restore one of these pocket estuaries for juvenile salmon.

Signage by the Island County Marine Resources Committee explains the history of the park's pocket estuary—both its loss when it was drained and filled to develop the state park and its importance to the marine ecosystem. This sign sits by the wetland swamp across from the picnic shelter. Cattails camouflage both the water and the mallards swimming in it. With Saratoga Passage's waters shimmering in the other direction, this little spot is frequently overlooked.

Camano Island State Park's Marsh Trail overlooks the marsh, Saratoga Passage and Whidbey Island. *Author's collection.*

The November 2013 *Final Recommendations Report to the Parks and Recreation Commission* proposed measures to protect the park's resources and reduce human impact. These included preserving quality natural, cultural and historic resources by using land classifications to specify the types of development and uses that could be allowed. The proposal also designated areas of the park to protect quality natural areas, as well as priority habitat and species, by restricting high-intensity recreational uses from those sections.

The report also looked at long-term boundaries for the park to see which areas might advance the conservation and recreation mission of the park based on their connectivity with park property, their ecological and future potential recreational values and interested landowners. There is a desire to extend park trails in the future to these areas, but no new camping or facilities would be planned for these properties. Instead, the additional acreage would enhance the natural corridor and also provide a visual buffer between the park and future residential development.

Cama Beach State Park

1994

TODAY

Cama Beach State Park takes visitors back to the time when individuals and families returned every year to relax, play, swim, boat and fish. However, Camano Island's crown jewel is more than a refurbished fishing resort with nature trails in the forestland. During the eighteen years it took to purchase and open the park, state park staff, the Risk family and descendants and various historic, cultural and community groups joined in the careful and deliberate planning of the park.

With Camano Island State Park one mile south of Cama Beach State Park, the intent from the beginning was for Cama to be a complementary park to Camano Island State Park. The Cross Island Trail links the parks and allows campers and cabin guests access to both parks.

Cama Beach State Park offers visitors two types of experiences in its 433 acres of mostly undisturbed forest with an extensive waterfront on Saratoga Passage. While people enjoy lounging on the beach or enjoying the various water activities, the park also protects a diversity of plants and animals on the beach and tidelands and in the upland forest.

At the park entrance, guests staying in the cabins can register at the Welcome Center. The center also provides visitor information and a natural history experience with its assortment of skulls and pelts that children can

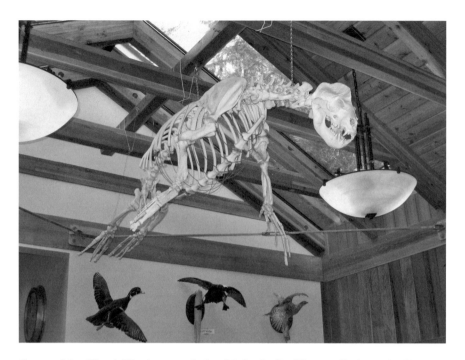

Camano Island Beach Watchers rearticulated Salty the Sea Lion, on display at the Cama Beach Welcome Center. *Author's collection.*

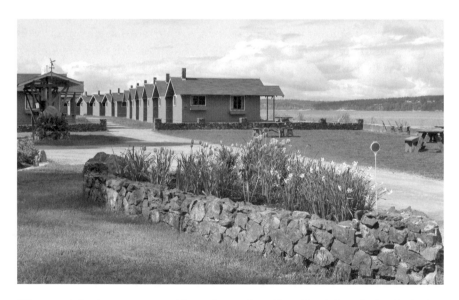

Volunteers helped restore resort cabins and grounds at Cama Beach State Park. *Friends of Camano Island Parks collection.*

investigate. Hanging from the rafters floats Salty the Sea Lion, which the Island County Beach Watcher class of 2002 rearticulated for its class project. To resurrect Salty, Beach Watchers boiled the blubber from the bones, dried the bones and reassembled the skeleton for display. The Welcome Center also sells Cama Beach mementos that include bags made by the Cama Beach Quilters, who also made the quilts for the cabin beds.

To ensure a quiet, natural experience, parking areas with native plants in between separate parking sections are on the bluff. Shuttle buses from the Drop-off Shelter transport people to the beach area and the cabins. Aside from special park vehicles, cars and trucks are not permitted in the resort waterfront area. For those choosing to walk from the parking area, the logging skid road and original Cama entrance now serves as a trail to the waterfront. At the bottom tucked in a cove of native bushes, a children's play area continues to offer swings. It's a steep climb back from the beach to the bluff and the parking, but shuttles are available.

At the beachfront, visitors can walk more than one mile (six thousand feet) of pristine saltwater beach. Behind a seawall, two rows of rustic beach cabins offer a waterfront living experience with the wind, waves, gravelly beach, driftwood logs, shells, ducks, seals and fish. Both the National Register of Historic Places and the Washington Heritage Register recognize the cultural significance of the beach resort. Glimpses of Depression-era history include rustic buildings, vintage machinery, old gasoline pumps, the resort fire engine and other transportation vehicles. The history of the fishing resort was showcased in the rehabilitation and maintenance of the resort facilities. Across from the store toward the beach, the old fire square, once used as a place for songfests and marshmallow roasts, continues as a gathering spot for picnics.

"Cama is the one place kids can run around or bike around down by the beach and be friends in all of twenty-seven minutes," said Jeff Wheeler, Cama Beach Area State Parks manager. "It's a safe place."

The resort's general store has reopened with snacks, supplies, environmental educational books and toys and a few souvenirs. It also has a small information center with historic displays and memorabilia from the original resort era, as well as information about park activities and local events. The store has seasonal hours and is run by volunteers of the Cama Beach Foundation. Proceeds support and develop educational programs and activities for visitors at Camano Island's two state parks.

The foundation designs and buys educational tools for teaching and trains volunteers. This includes inquiry-based learning experiences with skulls,

aquarium displays, microscopes and computers to teach visitors about the sea life in Saratoga Passage. Events are planned at both state parks to provide education about the beaches, waters and forestlands of the Northwest and to promote educational opportunities for visitors of all ages. Interpretive programs are scheduled many Saturdays. Programs often include an art or craft activity such as painting or drawing nature scenes, nature journaling and making ornaments, necklaces or baskets from natural materials. In the summer, the programs are also held during the week.

The foundation collaborates with organizations and Washington State Parks in several festivals at the park. CamOcean Day is a free festival for families to enjoy while learning about environmental issues affecting the ocean. The Open Air Quilt Show showcases the quilts made by the Cama Beach Quilters. Other festivals include an educational film festival, a Beach Art Festival and a Harvest Fest.

Cabin choices vary, with twenty-four standard cabins on the edge of the beach each with a living room, kitchen area and bedroom. Waterfront cabins have two double beds. Second-row cabins have a double bed and a set of bunk beds (twin size). Standard cabin amenities are electric heat, lights, refrigerator, microwave, coffee maker and sink. Restrooms and showers are nearby. Linen service is not available. Guests should bring their own bedding, pillows, towels, cookware, dishes and utensils.

Seven deluxe cabins have a small bathroom with shower, toilet and sink. Deluxe cabins have one double bed and two twin-size beds. These cabins have a view of the water. Two bungalows have a large front room, kitchen area, two small bedrooms and a bathroom with shower, toilet and sink. Large covered front porches look to the beach and Saratoga Passage.

The Center for Wooden Boats restored the historic boathouse. The center now rents traditional wooden boats at affordable rates and provides instruction for young and old. It also rents small sailboats, rowboats, motorboats and kayaks. The center offers boat-building lessons, including toy boats. At the annual Mother's Day weekend (Saturday) sail, moms and the rest of the family can view classic wooden boats, build toy boats and take a free boat ride.

The Center for Wooden Boats also has a Job Skills Training Program for young adults from low-income or underserved backgrounds to be job skills crew members. Crew members participate in all areas of the center's operations, focusing on general seamanship and on-the-water skills. An emphasis is placed on preparing students with the skills necessary for careers in the maritime industry, including helping students pursue United States Coast Guard credentials.

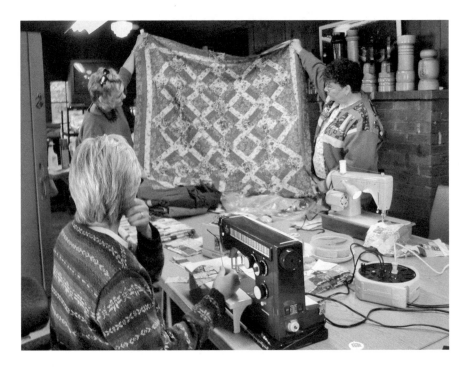

The Cama Beach Quilters made quilts for the beds in each cabin at Cama Beach State Park. *Washington State Parks collection.*

The Center for Wooden Boats rents boats and offers workshops at Cama Beach State Park. *Washington State Parks collection.*

The Washington State Parks Centennial GeoTour features 103 geocaches hidden in state parks across Washington. *Washington State Parks collection.*

The Cama Center, a dining hall and commons area on the hill between the parking area and the beach cabins, provides breakfast and lunch on the weekends all year and during the week in the summer. The building also serves as a gathering space. Other times, it is rented for group events.

A quieter Cama Beach State Park experience exists in the forest uplands, where visitors can hike the trails and listen to the eagles, woodpeckers and Pacific wrens. The forest consists of ninety-year second-growth Douglas fir, grand fir and hemlock. Cama Beach also provides a wildlife habitat for species of concern—bald eagles, great blue herons, pileated woodpeckers and red-legged frogs. Friends of Camano Island Parks built trails throughout the park, including the bluff above the historic beach area, and added viewing platforms of Saratoga Passage. Interpretive signage created by Eagle Scouts at the platforms provides environmental education, especially about native plants.

The bluff trail leads to the Welcome Center and to the West Camano Drive crossing for additional forest trails. Hikers can walk to Cranberry Lake, an open water wetland and the source of an intermittent stream that flows through the ravine to the Puget Sound shoreline. The Cross Island Trail through the uplands links to an Island County trailhead at Ivy Way, near Dry Lake Road. There is roadside parking and a small

park with a picnic area. Dry Lake Road serves as a 1.4-mile corridor to the Elger Bay Preserve.

Cama Beach has an interpretive specialist to ensure the environmental education park emphasis occurs at the historic beach area, the shoreline and the forestland. Volunteers for FOCIP, the Center for Wooden Boats, Cama Beach Foundation and Beach Watchers work in cooperation to provide a diverse selection of educational programs, activities and services. Some of the topics for both adults and children include plants, soil and forest ecology; geology, watershed and marine environment; humans and nature; birds and wildlife; Cama Resort; maritime history and boat building; Native American heritage; and geocaching. The park also has several special events with complementary activities and topics. An annual or one-day Discover Pass is required.

YESTERDAY

Situated on the west shores of Camano Island on Saratoga Passage, various Coast Salish tribes used the barrier beach and lagoon at Cama Beach as a summer camp and overnight site. During the warmer months, the Native Americans would leave their villages and spend several days to a few months near the lagoon. Here they would fish; dig clams; hunt seal or deer; gather berries such as salmonberries, cranberries and salal berries; dig roots of bracken ferns and cattails; and weave cedar bark into mats, baskets and clothing.

The Kikiallus, a tribe in the Swinomish Indian Tribal Community that occupied the south fork of the Skagit River and Camano Island, often camped at Cama Beach, which they called *Ya-Lked*. Ancestors of the Snohomish tribe, now part of the Tulalip tribes, also used the area as a seasonal camp and called it *WHEE-uh PUHK-wuhb* (place with a small promontory). Visitors of the camp also included ancestors of the Upper Skagit tribe, the Stillaguamish tribe and the Samish Indians.

A cultural resources survey completed in 1995 confirmed that a shell midden was located underneath much of the historic resort area of Cama Beach. An additional report in 2002 by Randall Schalk of Cascadia Archaeology determined that the predominant Native American activities were fishing and shellfish collecting. Fish and bird remains indicate the site was used primarily in the spring, summer or fall. However, remnants of winter sea ducks indicate that the area could have been used throughout

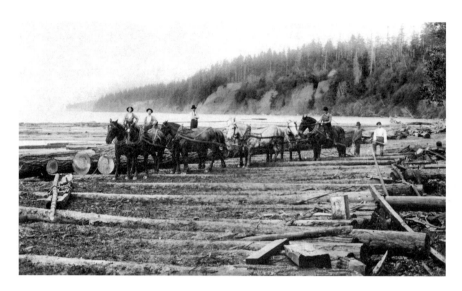

Thomas Esary operated Esary logging Camp #2 where Cama Beach resort was built. *Courtesy of Washington State Parks and Recreation Commission, Whitmarsh Collection, ID# 2014.1.1.*

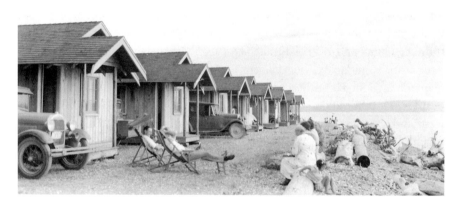

Resort lounging looks much like today, except shuttle vehicles now transport guests from the parking lots on the bluff. *Stanwood Area Historical Society 2002.57.020sp, circa 1939.*

the year as a stopping place for canoe travel between residential villages and harvesting sites.

Cama Beach Resort was eventually built on the deserted English Lumber Company's Camp 2, which stopped logging in the late 1890s. Later, Tom Esary, who owned three hundred acres of land around Camano City, established a sawmill in 1905. He ran the Esary Logging Camp at the

Cama site from 1905 to 1908. The main entrance to the resort began as a skid road built to drag logs down to a millpond. Another skid road area at the shore enabled logs to be dragged into Saratoga Passage and towed to the sawmill.

LeRoy Stradley, founder of Cama Beach Resort, discovered Camano Island during summer fishing expeditions to Ericson Island north of Stanwood, where he owned land. He purchased a house on Camano Island, which he called Cama Home, on a bluff at Camano City overlooking Saratoga Passage. After purchasing land on Camano Island, Stradley, a former publisher of the Seattle shipping paper the *Daily Index*, continued to acquire land, amounting to more than four hundred acres, including a mile of sand and gravel beach, hill land and the early logging camp site. With these purchases in 1933 and 1934, Stradley envisioned a resort for families to enjoy a vacation on the water for a low cost and have affordable access to fishing and small boat rentals.

Stradley hired unemployed men during the Depression, and after clearing the trees, filling the land and building more than forty cottages, the resort opened on May 19, 1934. The *Twin City News* stated, "Cama Beach is a $150,000 resort, which should mark the beginning of a new era on Camano Island." Brochures emphasized the island's accessibility, with the drive onto the island only sixty minutes from Bellingham and ninety minutes from downtown Seattle.

Stradley died in 1938, and his daughter Muriel and her husband, Lee R. Risk, took over the management of the resort. Risk handled the payroll during the resort's development and was listed as the manager on the first brochure. He and Muriel married in August 1934, just after the May opening of the resort. The Risks continued to operate the resort with the same mindset of Stradley—affordable accommodations and activities for families on summer vacations. Aside from the boathouse and seawall added in the 1950s, the resort maintained its original Depression-era character.

In 1984, the "Finest Saltwater Resort on the Coast" was the only resort remaining on Camano. It remained open until 1989. When fishing declined, the owners provided various activities to maintain the resort as a destination for family vacations. These activities included tennis courts, ping-pong rooms, swimming lessons, square dances, music and films. One Cama Beach brochure noted the "outdoor firesquare for songfests, wiener and marshmallow roasts." The brochure also included recipes for Cama Beach Baked Clams and Cama Beach Clam Chowder.

Karen Risk Hamalainen and Sandra Risk Worthington, Muriel and Lee's daughters, grew up playing and working at Cama Beach. After the resort closed in 1989 because of the declining health of Lee and Muriel, Karen and Sandra with their husbands, Asko Hamalainen and Gary Worthington, more seriously sought alternatives for Cama Beach Resort. However, the family had already begun exploring alternatives between 1977 and 1989, when annual revenues began declining as fewer people used the resort.

Reasons varied, but the many resorts on Camano Island had slowly closed as the salmon population declined in Puget Sound, self-contained recreational vehicles became more popular, people owned their own boats, air travel became more affordable, the highway system became more extensive and recreational interests changed. Adding to the lost revenue from the decline in vacationers, land values for waterfront property escalated, and along with that, so did property taxes. Subdividing resort properties and selling lots became more profitable than running the resorts. Yet Cama Beach continued on; having much of the Cama Beach Resort land designated as forestland helped to keep the taxes lower.

With the death of Muriel Risk on November 10, 1990, the family members sought a way to protect the essence of the Cama Beach Resort, both its historic and natural aspects. The family investigated alternatives such as a nonprofit nature center, a retreat center and nature conservancy or land trust donations. They also declined inquiries for development, including a golf course.

In the November 8, 1992 edition of *The Herald* of Everett, Karen Hamalainen stated, "What can I say? I love this place, but that doesn't mean I have to run it. It doesn't mean I have to own it. We just don't want to do a project not wanted by the local community."

The actual acquisition of Cama Beach into the state park system was a lengthy process that took eighteen years. The first meeting with the Washington State Parks and Recreation Commission occurred on December 11, 1990. Sandra and Gary Worthington met with Cleve Pinnix, at the time the deputy director of state parks. After showing the maps and photos of the resort, the Worthingtons said this could be preserved for the public. With Pinnix's interest sparked, he passed on the information to others in the agency.

This began many meetings with state parks and other public agencies to pursue public access. Gary Worthington developed an "Owners' Guidelines for Public Use of Cama Beach" in June 1991 to outline the owners' preferences for the development of a public park. The guidelines set up a standard for selling the park and included:

- All park development should be environmentally sound.
- The greater part of the forest cover and wildlife habitat should be retained as a natural preserve.
- Buildings should be energy efficient and appropriately designed for the setting.
- The park area should be a quiet, peaceful place for reflection and appreciating the natural environment.
- Some remnants of the historical use of the property as a resort should be retained.

In 1993 and 1994, the Center for Wooden Boats, needing additional space beyond Seattle, negotiated an interim use agreement with the family to use the boathouse area and three adjacent buildings. This agreement included the expectation that the lease would continue with Washington State Parks. Designated by state parks as an "anchor program" and "enduring partner," the Center for Wooden Boats became involved in the acquisition and planning of the potential park.

Meanwhile, Karen Hamalainen, living on Camano, began seeking community support for the project. With the aid of Friends of Cama, a volunteer group formed in March 1993 to help create a Cama Beach State Park, the family continued to approach the Washington State Parks and Recreation Commission with the idea to open the historic 1930s-era resort to the public. Their intent was also to preserve the natural and historic significance of the site. The proposed park uses included a trail system for hiking and interpretive education, beachfront activities, a Center for Wooden Boat office and shop and overnight lodging in the cabins.

Friends of Cama began promoting the concept of a low-impact state park to complement Camano Island State Park's camping and boat launch activities. Ole Bakken and Roy Hobbs, members of the public relations committee, sent a letter to community members seeking support:

This new Cama Beach site would be supplemental to, but not in competition with, the existing State Park, with its emphasis on RV's and Power Boats. Our emphasis would be on peace and quiet (nature trails, hiking, sailboats, rowboats, kayaks, etc.). Our group has many supporters already, including officials in Olympia, and the Washington State Parks and Recreation Commission. However, we would be most grateful for any additional support you might be able to provide, because we need to ensure that the Cama Beach acquisition is included in this year's Budget. That depends on public support!

Karen Hamalainen promoted Cama Beach before the resort, once owned by her and her sister Sandra Worthington, became a state park. *Washington State Parks collection.*

The Friends of Cama group also circulated a brochure stating its goals of promoting the purchase of the property by the state parks system; preserving and protecting the environmental and ecological qualities of the property from other types of development; and preserving, restoring and maintaining the historical significance of the early twentieth-century family resort. It requested help on committees, donations for promotion and letters of support to state park officials, the governor and legislators. The group also offered Sunday tours of the property, as well as speaker presentations that included a slide show.

Cama Beach State Park actually opened to the public on June 21, 2008, after a series of sales and matching donations over several years as the family and Washington State Parks Recreation and Commission worked to plan and develop the park. With funds appropriated by legislators as part of the Washington Wildlife and Recreation Program, the purchase was spread over three biennia, requiring legislative appropriation for each phase. The owners provided matching land donations of close to $10 million (60 percent). They also gave cash donations for the park's master plan and the Cama Center dining hall.

During the eighteen years it took to open Cama Beach State Park, the island's state parks were organized into the Cama Beach Area in the state park system. Jeff Wheeler became the area manager in 2001. Between 1999 and 2006, while project delays occurred due to tribal concerns that involved archaeological survey work in the beach area, multiple volunteer groups became engaged in various aspects of the park to help create the new state park and have it ready for the grand opening.

Four years before opening the park, Wheeler and park staff hosted an Active Volunteer Summit on June 19, 2004, to recognize all the volunteer organizations involved with preparing the park. The Center for Wooden Boats renovated the buildings it would use at Cama. FOCIP developed trails throughout the park. The Cama Beach Quilters made enough quilts for the beds in every cabin. The Cama Beach Woodworkers made cabin benches, Adirondack chairs, cabin tables and picnic tables. Four years later, the same groups were back, along with the family and state officials, for the grand opening when Cama Beach State Park officially opened to the public and continued the resort's tradition of providing a place where individuals and families returned yearly to enjoy its unique qualities and savor the memories.

LEGACY

Founded on partnerships, Cama Beach State Park is a legacy of community cooperation. The partnerships originated with the beginning of the acquisition process when Karen and Asko Hamalainen and Sandra and Gary Worthington began talking to the Washington State Parks and Recreation System, the Center for Wooden Boats, community members who formed Friends of Cama and the elected officials who eventually appropriated the funding. The partnerships continue today with both the caretaking of the park through FOCIP, the quilters and the woodworkers, as well as the environmental education opportunities through the Cama Beach Foundation and the Island County Beach Watchers. That collaboration will continue.

While advocating the acquisition of Cama Beach into the state park system, sponsors prepared the Cama Beach State Park Vision Statement. This highlighted Cama Beach State Park as a footprint of the past and a step into the future. The vision combined the contemporary park and educational facilities with its historic beachfront. It also promoted an appreciation of the park's diverse natural and cultural resources.

John Custer, Cama Beach Foundation, provides opportunities for learning about beach life at Cama Beach State Park. *Washington State Parks collection.*

The park's master plan included an Environmental Learning Center with modern lodging for a retreat center. After Cama Beach opened, the state park system began selling a one-day or annual Discover Pass to help maintain state parks. Lack of funding has put the Environmental Learning Center on hold.

The partnerships also led to even more connections. While the family was working with the state parks system and state legislature, FOCIP worked with local property owners and Island County through Conservation Futures funding and easements to provide connector trails into the park.

From the south along the roadside, the trail to Camano Island State Park was constructed. FOCIP encouraged Island County to implement the county's 1995 Non-Motorized Trails Plan for this connection by surveying Lowell Point Road to determine if there was enough existing county easement for a trail between the parks. Island County did so, including acquiring an easement of a small north section of property needed to make the connection to the Cama Beach portion of trail.

In the forest uplands, the Island County Cross Island Trail was established at the Dry Lake Road Trailhead. Later, an additional two and a half acres

was added to create the Dry Lake Road Trailhead picnic area. The FOCIP-sponsored Camano Island Non-Motorized Trails Committee sought this backdoor entrance to Cama Beach in an attempt to link three public lands (Camano Island State Park to Cama Beach State Park to Elger Bay Preserve) with a trail.

These extensions to Cama Beach State Park add natural buffers for wildlife corridor protection. That protection continues with neighbors adjacent to the land. In 2012, Joe and Cathy Holton protected their thirty-one-acre property from future development by working with the Whidbey Camano Land Trust to place a conservation easement on their land. Three generations in the Holton family agreed that keeping the property wild and free from development was a priority. "We have a connection to the land," said Joe Holton. "We believe this is the highest and best use of our property and can only hope through our efforts, we inspire other gifts of conservation."

While the land remains in private ownership with the Holtons, the conservation easement ensures the land remains natural and free from development. The land has a mature forest, wetlands and a peat bog and is part of the wildlife habitat corridor between Cama Beach and Camano Island State Park.

During the Whidbey Camano Land Trust celebration honoring the Holtons, Randy Reeves—son of Joe and Cathy Holton, who are members of FOCIP—mentioned how Carol Triplett, co-chair of Friends of Camano Island Parks, had inspired his parents and planted the early seed for them. "The FOCIP organization is phenomenal. The community as a whole is so enriched by them."

Perhaps one of the largest legacies the acquisition of Cama Beach State Park has had for the Camano Island community is the creation of Friends of Camano Island Parks, formerly Friends of Cama. The organization, led by Triplett as co-chair, since it began has participated in the acquisition, development and maintenance of most of the parks on Camano Island. Strong co-chairs have helped the organization as well. Pam Pritzl served for many years, and her birding expertise has helped recognize Port Susan and Skagit Bays as Important Bird Areas recognized by the Audubon Society. Tom Eisenberg became the co-chair in the late 2000s, and his leadership has been instrumental in trail construction at Cama and other island parks, as well as the construction of platforms, bridges, benches and kiosks.

Truth be told, if it weren't for FOCIP, most of the natural parks and preserves on Camano Island would not be protected.

Dry Lake Road Trailhead

1997 AND 2007

TODAY

The Dry Lake Road Trailhead usually isn't a destination in itself, but it could be. It's a hub that serves both as a trailhead and a picnic rest stop. This area was established to serve as a trail junction between the state parks and Elger Bay Preserve. With parking at the Ivy Way cul-de-sac, hikers will find a trail into Cama Beach State Park, a route to Elger Bay Preserve and a short trail with a picnic table and kiosk.

Most people use the Dry Lake Road Trailhead as an access to the Cross Island Trail through the upper section of Cama Beach State Park to Cranberry Lake and other features of the state park. After crossing West Camano Drive, the Cross Island Trail continues to Camano Island State Park, which is a 2.4-mile trip from the trailhead.

The Dry Lake Road Trailhead is also an access to the Elger Bay Preserve trails. Hikers can walk a quiet 1.4 miles along Dry Lake Road to the Elger Bay Road intersection and enter the preserve's trails.

This trailhead junction does have its own natural attractions, including a wetland stream that drains into Cranberry Lake. Near the intersection of Dry Lake Road and Ivy Way, an interpretive kiosk, picnic table and short trail provide an opportunity to savor the quiet of the inner island.

The Dry Lake Road Trailhead serves as a junction for hikes to the state parks and Elger Bay Preserve. *Tom Eisenberg*

Despite the small area, it provides an excellent spot to watch and listen as the natural world unfolds. The property is a woodland mix of second-growth coniferous western red cedar, Douglas fir and western hemlock with deciduous big leaf maple and red alder trees. The forest understory of red elderberry, red huckleberry, Indian plum, salmonberry, salal, Oregon grape and sword fern on the slope merges with wetland native plants in the ravine.

Looking at the forest, visitors will see springboard notches in the stumps that showcase the land's history. In early logging days, springboards were used by the fallers to stand on when cutting the huge old-growth timber with their crosscut saws. The tree snags also reveal evidence of pileated woodpeckers thriving. This trailhead junction enhances the wildlife corridor for coyote, porcupine, deer, owls and woodpeckers. The table in the woods near the wetland offers a nice spot to observe and see what else calls this spot home.

YESTERDAY

Like most other places on Camano Island, this area was originally logged, as can be seen by the stumps with the springboard grooves. After the logging, the land has had time to rejuvenate with its location away from the shoreline and close to the 433-acre Cama Beach State Park.

During the eighteen years it took to open the state park, Friends of Camano Island Parks worked with local property owners and Island County using Conservation Futures funds to provide a northeast entrance to the state park and also a connection to Elger Bay Preserve. The Camano Island Non-Motorized Trails Committee, sponsored by FOCIP, sought this entrance to Cama Beach in an attempt to link the state parks to Elger Bay Preserve.

FOCIP sponsored two Conservation Futures Fund applications to acquire land at the Dry Lake Road Trailhead. In 1997, the first acquisition of 2.1 acres—which included a thirty-foot-wide and two-hundred-foot-long county easement to the park—made it possible to connect to the northeast portions of the Cama Beach property. Karen Hamalainen, one of the former owners of the Cama Beach property, matched the Conservation Futures funds to assist in creating the trailhead. Her confirmation of the donation noted the trailhead's link to the Department of Natural Resources (DNR) land, later known as Elger Bay Preserve. Hamalainen wrote in her letter confirming a $9,000 match to the Conservation Futures Fund to purchase the 2.1 acres of Phase I:

> *Naturally as…owners of Cama Beach, who actively participate financially and in energy in the plan for Cama Beach State Park (approved by the Washington State Parks Recreation Commission), we wish to see active use of Cama's proposed trail system with its connecting links to Camano State Park and indirectly to the South DNR land on Camano and Elger Bay [roads]. This purchase if approved will greatly enhance access from the east while educating and encouraging wise use.*

Later, in 2007, an additional 1.9 acres adjacent to the 2.1 acres were added to the Dry Lake Road Trailhead. FOCIP submitted the funding application after working with a neighbor willing to sell the land at nearly half its assessed value.

Both pieces of property contain a year-round creek that feeds into Cranberry Lake on the Cama Beach property. After protecting the two

Carol Triplett, FOCIP co-chair, and FOCIP volunteers built a new trail at the Dry Lake Road Trailhead. *Tom Eisenberg.*

properties, FOCIP constructed a short trail above the wetland and stream. The group also added the kiosk and table to assist with education, as well as provide a rest area for trail users.

LEGACY

The Dry Lake Road Trailhead project provides another lesson in connections. By opening a northeastern access to Cama Beach State Park, more of the locals connect with the park. With the backdoor entrance, the park suddenly becomes a neighborhood park for residents rather than a not-so-distant state park luring out-of-area visitors. People care for the places close to them.

The connections extend to trails that allow people to travel from Elger Bay Preserve to Cama Beach State Park to Camano Island State Park—without getting into a car. Traveling through forests, by streams and wetlands

and along the shoreline in these three protected areas provides a quality experience of the natural features of Camano Island.

On a larger scale, the area provides an opportunity to preserve more wildlife habitat and protect a wetland. The wetland from this property feeds Cranberry Lake before flowing into Saratoga Passage. This aquifer and watershed preservation sustains the water retention ability of the wetland and enhances the wildlife corridor. Tom Riggs, Cama Beach Area State Parks assistant manager, wrote in support of the Phase II addition to the Dry Lake trailhead:

> *What could be argued as the "higher and better purpose" of the Phase II acquisition, is that of conservation. The eastern portion of the Cama Beach acreage also contains Cranberry Lake, which is part of one of the few fresh water watersheds on Camano Island's west side. The 1.9 acres proposed for purchase in Phase II contains portions of a stream that feeds Cranberry Lake. As with all watersheds, the more protection you have upstream, the better life is downstream.*

The coyote, porcupine, deer, great horned owl, downy woodpecker, hairy woodpecker, pileated woodpecker, Bewick's wren, Pacific wren, rufous hummingbird, spotted towhee, song sparrow, fox sparrow, red-breasted nuthatch, chestnut-backed chickadee, black-capped chickadee and other wildlife added to a visitor's list while watching and listening at the picnic table probably would agree.

English Boom Historical Park

1997

TODAY

Counter to the bustling days of logging, English Boom Historical Park now is a peaceful spot on Puget Sound that rarely has a crowd. What's special about the area is the proximity of the uplands, salt marsh, shoreline and tidelands.

It's a place that warrants multiple visits because no two visits are ever the same. Some visits will truly be at the water's edge of Skagit Bay with waves splashing the shoreline as Caspian terns, ospreys and kingfishers dive into the bay for fresh fish; other days, the bay will be an endless mudflat with western sandpipers, dunlin and killdeer scurrying about the mud, herons standing stoic and seals hauled out on a sandbar soaking in the rays. Meanwhile, peregrine falcons and eagles roost in the trees watching for an opportunity.

Even better, stay awhile and see the transition and be part of the cycle. English Boom is one spot to sit back against the driftwood and watch the tides rise and fall. During the wait, much will happen as the critters of the wild forage, roost and squawk, living out their day.

This seven-acre park with nine hundred feet of waterfront on south Skagit Bay is one of the best places along Camano Island to see a rich diversity of birdlife. The upland portion is forested with Douglas fir, western red cedar, western hemlock and alder trees providing perches for raptors. The understory vegetation includes ferns, salal, Oregon grape, red huckleberry

A walk along the marsh and meadow includes driftwood by the trail at English Boom Historical Park. *Tom Eisenberg.*

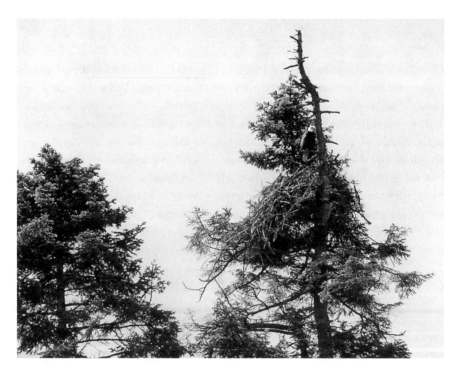

An eagle roosts by its nest at English Boom. Eagles nest in several locations throughout Camano Island. *Author's collection.*

and other native plants offering habitat for lowland forest birds. A steep bank links the upland area to the wetland at the base.

From the base of the slope to the shoreline, it is a mostly level saltwater beach and marine wetland that supports nootka rose, gum weed, yarrow and grasses such as beach blue grass. Driftwood, saltwater channels and pools are also present between the bank and the shoreline.

The northern exposure of the park protects it from the direct force of winter storms from the south. However, thick jumbles of driftwood in the marsh are evidence of some volatility. On a clear day, visitors can see Mount Baker and Mount Pilchuck.

English Boom lends itself to bird-watching, nature photography, walking and environmental education. Birding groups frequently plan field trips to this spot. Birders see an abundance of shorebirds and dabbling ducks on the mudflats or shallow waters. The deeper water offshore provides a habitat for diving ducks from October through April.

It's a birding hotspot for migratory birds such as teal, wigeon, pintail, goldeneye, grebe, sandpipers and dunlin, plus habitat for bald eagles, osprey, peregrine falcon and other raptors. Citizen science documents the area's bird population during the annual Audubon Christmas Bird Counts. Shorebird studies document the use of the area during the winter, as well as fall and spring migrations. In 2012, the Greater Skagit and Stillaguamish Delta was designated a Western Hemisphere Shorebird Reserve Network site of regional importance. In 2013, Audubon recognized Skagit Bay as an Important Bird Area site of global importance.

The road end has a few parking spots with level handicap parking access to a natural, undeveloped shoreline, as well as ADA access to a boardwalk and viewing platform adjacent to the beach. A short, level path leads to the beach from the parking lot shelter with a picnic table.

A trail parallels the shoreline to the east between the marsh and the upland slope. Planks bridge small tidal channels. During the winter's high tides and storms, the trail may be submerged, with logs and the bridges rearranged until a spring cleanup. The .9-mile round-trip shoreline trail is partially on public easement.

A kiosk with a historical display explains the pilings in the bay, providing reminders of the logging history of English Boom. A family memorial fund and Friends of Camano Island Parks donation made the display possible.

Environmental learning through access to this beach area includes signage describing the marine area, bird habitat and the importance of natural, saltwater shoreline and wetland preservation. This signage created by the

Island County Marine Resources Committee explains how the great blue herons use the estuary, how it's also a salmon nursery for the juvenile salmon leaving the Skagit and Stillaguamish Rivers and how the Saratoga Marine Stewardship area ecosystem supplies the varied wildlife.

A boat launch is also available for kayaks and other small boats. Silt and sediment carried through the Skagit River waters into the bay from the logging days have added to the extremes between high tide and low tide. But as long as kayakers and other boaters understand the variation and carry a tide chart, life on the water can be most enjoyable.

Yesterday

Even though by the 1920s nearly all the old-growth timber had been logged on Camano Island, logging still had a presence on the north end at English Boom. Located on the southern shores of Skagit Bay was the site of a bustling timber industry from 1922 to 1945. The pilings rising out of the water were pounded into the tidelands around 1922 and are all that remain of the settlement of piers and shacks.

During the 1920s and 1930s, the English Lumber Company logged the forests east of Stanwood and Mount Vernon. After transporting the logs by rail to the Tom Moore Slough at Milltown, the Tom Moore Boom Company sorted, graded and rafted the logs in Skagit Bay. Tugboats then hauled the floating logs to sawmills around Puget Sound.

In 1922, the English Lumber Company needed more space for grading, sorting, storing and rafting logs. The company hired Martin Tjerne, who in 1908 had worked for the Tom Moore Boom Company, a subsidiary of English Lumber. Tjerne built a storage area along the shoreline waters to collect the fir, cedar and other logs prior to being hauled to the sawmills. The tidelands and shoreline at English Boom became log storage yards called log booms.

While today the bay may be filled with thousands of sandpipers and dunlins scampering the sands or soaring above the water, during the active logging days, thousands of logs crowded the bay waiting to be hauled to the sawmills. During an interview with *The Herald* of Everett in September 1970, Tjerne noted those bustling days of English Boom.

"By 1922 we were too crowded in the Skagit, so English Logging hired me to build a boom across the bay on the end of Camano," Tjerne said. It was all done by hand. "We sorted 12 different grades of logs at the boom.

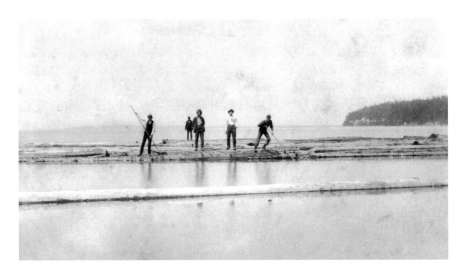

Boom men with their pike poles work the logs in Utsalady Bay. English Boom is nearby to the east. *Stanwood Area Historical Society 1996.37.03, circa 1920.*

We rafted millions of feet of logs. At one time we had 15 million feet of logs stored; and Soundview Pulp and Timber, who rented the western section of the boom, had up to 10 million feet in storage."

For a time, the English Lumber subsidiary, Tom Moore Boom Company, employed about twenty men. Facilities at the boom included a dredge and two tugboats, the *Gordon T.* and the *E.G. English.* In 1928, the *E.G. English,* a former passenger stern-wheeler converted into a tugboat to haul logs to Stanwood one to two times a week, was fitted with a spud (spade or shovel) to help keep the channel clear. English Boom closed in 1945 when the English Lumber Company was sold to the Puget Sound Pulp and Timber Company, which eventually merged with Georgia Pacific in 1963.

Throughout the years of the log boom operations and after its closure, the public accessed the shoreline at English Boom for hunting, fishing and recreation. In 1928, Camano Islanders petitioned the Island County Board of Commissioners to create a county road from Utsalady Road along the section line boundary north (now Moore Road). An order on January 7, 1929, granted a deeded right of way with the intent to provide access from Utsalady Road to the water. That road served as access to the boom site for not only workers and company employees but also hunters, fishermen, clam diggers, picnickers and others accessing the tidelands for recreation.

English Boom was not public property until 1997. However, even published guidebooks led visitors to the old boom site on the shores of Skagit Bay. "A pretty spot at any time, but incredibly impressive during clear weather when the mountains emerge to add their splendor…much to see—mountains and foothills, islands and delta, all blending in a misty gray-green mosaic," according to Marge and Ted Mueller in *North Puget Sound: Afoot and Afloat* in 1988.

Harvey Manning wrote in *Footsore 3: Walks and Hikes Around Puget Sound* in 1981:

> *Views on a crisp-clear winter day are stunning. The ice mound of Baker and Twin Sisters dominates but also grand are peaks enclosing the Skagit delta—Woolley Lyman, Chuckanut, Blanchard, Devils, Cultus. South are Three Fingers, north are Canadian giants. The centerpiece is the broad expanse of Skagit Bay from Whidbey Island to Ika and Craft Islands, the entire Fir Island segment of the Skagit delta, and the whole Stillaguamish delta.*

Despite Moore Road having been used and maintained as a county road accessing the shoreline for years, representatives of Eagle Tree Estates blocked Moore Road in 1989 where the county road ended at the residential development property. In 1995, Moore Road residents filed a lawsuit over the disputed strip of Moore Road that accessed English Boom.

The trial determined that during the first half of the twentieth century, the disputed strip was used, along with the rest of Moore Road, as access to the tidelands and waters of Skagit Bay. Besides use by the truckers and others connected with commercial log rafting and the regional timber industry, hunters, fishermen and others seeking access to shoreline and water used Moore Road to access the beach. The recreational use was not just by neighbors in the vicinity but also by the general public because it was one of the few accesses to water on north Camano Island.

In a July 1989 letter submitted at the trial as Exhibit 13, Gordon Tjerne, mayor of the city of Monroe, wrote:

> *It was brought to my attention that the road leading to the Tom Moore Boom Company site (Island Boom) has been closed by a private developer. That road has always been an access road to the Island Boom site. The Tom Moore Boom Company maintained the road for the use of the company and company employees with unrestricted use by hunters, recreationists, and locals. It was for years the only access road to the water on the north end of Camano Island.*

My first memories of the Boom Road dates back to 1919 when I lived at the Island Boom site with my parents. My father, Martin Tjerne, was manager of the Tom Moore Boom Company for forty (40) years. In my late teens, I cut brush along the road to keep it passable.

The Boom Road has historically been an access to the beach and Skagit Bay. It would be a shame if rescue equipment couldn't get to the water as hunters and sportsminded people are still using the area for recreation.

Testimony in the trial showed that Moore Road had served as access to the boom site continuously by the public for more than ten years. Island County also maintained the road for more than seven years, which it did between 1936 and 1973 annually with gravel replacement and road repairs. With those requirements met, Moore Road was considered a county road according to Washington State law.

After the legal battle to reopen Moore Road, Carol Triplett, co-chair of Friends of Camano Island Parks, contacted the property owner, Mrs. Merle Morris, in December 1995 about the potential of turning her property into a nature preserve. Several months before that meeting, FOCIP formed and sponsored the Camano Island Non-Motorized Trails Committee to implement the Island County Non-Motorized Trails Plan developed by the county in 1995. The plan included English Boom as a potential area for a natural shoreline trail toward the mouth of the Stillaguamish River as it enters Skagit Bay.

During the meeting with Triplett, Morris showed an interest in having her land become a preserve. She also stated that she'd like to keep the property in as natural a state as possible with no picnic tables or fire pits, that she'd like the property to have interpretive boards and bird-watching activities and that she'd like it to have a shoreline primitive trail to view birds from different points.

In May 1996, Morris and Triplett had a meeting with Lee McFarland, county parks superintendent, and Tom Shaughnessy, county commissioner. In November 1996, Morris and her family indicated their support of the acquisition of their property for a natural preserve.

"It is necessary to have the support of the community as part of this application process," Triplett wrote in a January 16, 1997 letter to Morris prior to the upcoming public workshop concerning her property. "The purpose of the workshop is to inform people of ideas for the potential park and to gather support and input."

Watch for swallows soaring above the marsh while at English Boom Historical Park. *Robert N. Cash.*

At least forty-five citizens attended a public hearing about the purchase of the property with Conservation Futures funding. With response sheets available for immediate feedback, thirty-three people responded favorably, including the neighbors in the area; there were no negative responses. Letters of support for the purchase came from the local Audubon organizations, the North Cascades Institute, the Native Plant Society, the Stanwood Lions, state senator Mary Margaret Haugen and local citizens.

"I am for the acquisition and development of the park. I have been on Camano since 1947, through a summer home and now a retirement home. Growth has eliminated many of the beach access areas that were available at that time. I like the idea for the park because it will allow my grandchildren to enjoy island beach," wrote James Swanson.

Purchase of the land for the English Boom Historical Park was made possible through the efforts and sponsorship of FOCIP. In the Conservation Futures Fund application, FOCIP stressed the unique opportunity to acquire and protect waterfront property and access not readily available on Camano Island, especially north-end beach access. The organization also committed to providing stewardship through litter and trail maintenance, education with interpretive boards and materials and labor for viewing platforms, trails and trail markers.

The property was acquired in 1997 and was the first public property on Camano Island purchased with Island County Conservation Futures funds. This conservation program created by the state allows individual counties to make purchases of environmentally significant land parcels. Money is collected through a very small portion of property taxes (5.565 cents per $1,000 in 2014).

Later, initiated by family, community and business donations, the ADA boardwalk and platform near the beach were built, along with the picnic shelter. FOCIP added a kiosk to provide a history of the logging boom era. The Island County Marine Resources Committee created signage about the Davis Slough Heronry, salmon nurseries and Saratoga Passage to raise awareness of the assets of the shoreline and to promote an ethic of stewardship in residents and visitors.

Legacy

Preservation of this early-era log boom site not only provides an opportunity to retain the historical significance of the English Boom shoreline but also protects a unique ecosystem, open space and wildlife habitat for the general public to visit. In an area surrounded by increasing residential development, English Boom Historical Park is all about nature's connections.

The preserve's shoreline is not just an isolated area. It is part of an extended shoreline that exists to the east as far as the mouth of the Stillaguamish River. It is also part of the Greater Skagit and Stillaguamish Delta that is designated a Western Hemisphere Shorebird Reserve Network site of regional importance.

The conservation value of English Boom in Skagit Bay is continually cited for bird migration and the diverse population of birds and ducks. Pam Pritzl, Skagit Audubon past president, working with Ruth Milner, Washington Department of Fish and Wildlife biologist, nominated Skagit Bay as an Important Bird Area (IBA) recognized by the Audubon Society. By collecting information from a wide variety of sources and studies coordinated by Milner on the species and numbers of birds that frequent the bay, Milner and Pritzl jointly completed the complex nomination. After passing the Washington State IBA criteria, the nomination moved to the national committee.

In August 2013, Audubon recognized Skagit Bay as an Important Bird Area site of global importance. Data shows that Skagit Bay supports more

Pam Pritzl, past Skagit Audubon president, leads birding trips at English Boom Historical Park. Skagit Bay is recognized as an Important Bird Area. *Author's collection.*

than 5 percent of the North American population of at least four species (trumpeter and tundra swans, lesser snow goose and dunlin) during a season or more than 1 percent at a given moment, which meets the IBA criteria for "Globally Significant." This is the highest designation a site can receive.

Hal Opperman, PhD, in a 1997 letter supporting the acquisition of English Boom, wrote:

> *The north end of Camano Island often leads all other sectors of the Skagit Bay Christmas Bird Count (CBC) in total number of species. This year's count found the astonishing number of 87 species there on New Year's Day. Overall, we have tallied a total of 118 species in the area since 1989. This is all the more remarkable when one considers that the Skagit Bay circle set the record one year for the most individual birds seen (all species combined) in any CBC count circle in North America, some 134,000 birds. And never has the Skagit Bay count fallen below 100,000 individuals. English Boom is a window onto one of the greatest natural areas in the United States.*

Through the years, the area Audubon societies have been actively working with the Washington Department of Fish and Wildlife, especially Milner. Citizen science through bird counts, along with flyovers and banding with funding from grants, have all been documenting the area as critical habitat for bird migration, particularly shorebirds. Having English Boom remain a natural preserve with passive public visitation helps protect this ecosystem for the shorebirds, heron, salmon, raptors, deer and raccoons. It also hosts visitors wanting a quiet spot to gaze at snowcapped mountains over turquoise waters while watching gulls soar, hearing eagles chatter, feeling the sea breeze, sniffing wild roses in the air and maybe even devouring a juicy berry or two.

Iverson Spit Preserve

1999

TODAY

Despite the twists and turns necessary to arrive at Iverson Spit Preserve, once there, all that's really needed is a pair of binoculars. Watching birds is the thing to do at Iverson, so much so that Audubon Washington placed it on the *Great Washington State Birding Trail Map: The Cascade Loop*.

Between the forested bank and the southwest corner of Livingston Bay, many types of bird habitats can engross an avid birder for hours. With the shoreline, marshes, shrubs and forest, more than 125 species have been recorded in the preserve, where its food, water, shelter and places to raise young meet the qualifications necessary for an Important Bird Area. The preserve is within the Pacific Flyway and is part of the Port Susan Bay IBA, one of fifty-three IBAs in the state identified by Audubon Washington.

From the parking lot, steps lead to a viewing platform of Livingston Bay. During the winter, this is habitat for diving and dabbling ducks. Besides the dunlins that spend the winter, thousands of shorebirds migrate through in the spring and fall. Iverson Spit Preserve is part of the Port Susan Bay and Skagit Bay combined area recognized for its regional importance by the Western Hemisphere Shorebird Reserve Network.

Views of the Cascades, especially Mount Baker, dominate the skyline to the east and northeast. From the platform, there's access over the dike to

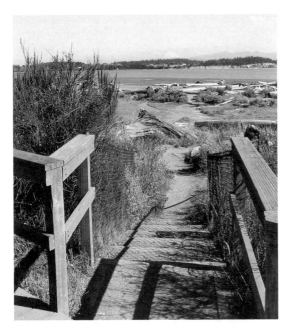

Using beach stairs protects the dike at Iverson Spit Preserve. *Author's collection.*

the shoreline. Through a maze of driftwood logs, birders and beach walkers can climb over and twist through to reach the beach. The area has extreme tides, so the water's edge may not be too close or it may be very close. Exploring the beach offers plenty of options, including visiting some elaborate driftwood forts. The shoreline is extremely popular during the warmer months for families and groups to gather, walk and play.

Onshore and offshore fishing are popular. During salmon runs, large numbers of sport fish migrate just off the sandbar. During the winter, the area is popular for sport sturgeon fishing. Offshore recreational crabbing with crab pots or short-handled dip nets while wading from shore is a seasonal activity that requires a fishing or shellfishing license with a Puget Sound crab endorsement.

Hikers can walk the Loop Trail (.9 mile) starting along the dike for a view of the estuary, bay and mountains. A bench provides opportunities for lingering. The trail drops behind the dike through thickets of salmonberry and thimbleberry and along freshwater and brackish marshes. After crossing the bridge, there's a direct exit route that's more open with the dike and madrona trees on one side and native rose skirting the field on the other side. An alternative exit trail, the Hobbit Trail, goes through a crabapple thicket before crossing an open field to join the main exit trail.

The approximately 1.3 miles of trails are relatively flat and easy to walk during the dry season. Because parts of the trails are located in seasonally wet areas, Friends of Camano Island Parks placed planks in select areas to improve trail conditions during wet and muddy times.

The amenities within the preserve include a small parking area, trails, a seasonal portable toilet (porta-potty) and an active agricultural field. There

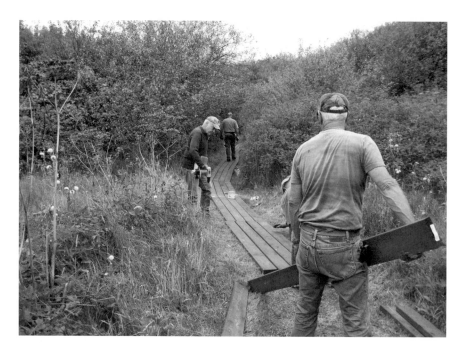

FOCIP volunteers build a plank walkway on the trail at Iverson Spit Preserve to reduce mud exposure during wet weather. *Tom Eisenberg*

are two picnic tables and an information kiosk just north of the parking area. Three staircases access the beach area to protect the dike. The southern staircase also has an overlook. An interpretive sign lists birds potentially present at the preserve. The Island County Marine Resources Committee created signage explaining the marine stewardship area and ecosystem of Port Susan Bay.

The shoreline and uplands are also used for outdoor environmental education activities. Organizers include teachers, environmental organizations, tribes and government agencies. Audubon and other groups frequently use Iverson Spit Preserve for birding trips. The Port Susan Snow Goose Festival in February places naturalists at the preserve during the festival.

Island County leases sixty-eight acres of the site for commercial farming. Farming activities have focused on seed production, as the area is protected from winds.

YESTERDAY

Iverson Spit Preserve, formerly the Iverson Farm, is located on the southwestern shore of Livingston Bay at the northwestern corner of Port Susan Bay. The bay separates Camano Island from the mainland. In the early twentieth century, the West Pass of the Stillaguamish River was dredged to link Port Susan Bay to Skagit Bay. This also linked the mouth of the Stillaguamish River to the small estuary at Iverson Farm, located directly west. The estuary's proximity to the mouth of the Stillaguamish River continues to influence its freshwater volume and its sediments.

The Iverson Farm was part of the pioneer heritage of Camano Island. The island's farms typically occupied land that wasn't necessarily ideal—stump land from logging or mudflats of the tidelands. Both types needed much work to be able to use.

O.B. Iverson, who had farmed in Iowa and South Dakota with some misfortune from hail and grasshoppers, scouted the Stillaguamish region and liked what he saw. He went back to South Dakota to encourage his friends to move west with him, and they did. In 1875, Iverson, Nils Eide, N.B. Leque and A. Danielson arrived together on Leque Island in a Native American canoe. These area pioneers began their farming legacies by buying land on Leque Island, in between Stanwood and Camano Island.

In the late 1800s, Iverson bought fifty acres that were adjacent to Peter Leque's more than ninety acres. Leque diked the tidewater mudflats of Port Susan to create the farm fields that are now part of the Iverson Spit Preserve. Around 1903 to 1904, Edward Iverson, who had taken over his father O.B.'s farm, purchased Leque's land. The long spit, formed by incoming tides and sediment connected to the farmland, became known as Iverson Spit. This spit would later be platted as Long Beach and sold for summer houses.

While Iverson farmed on the western shore of Livingston Bay, he would buy oats and hay in Stanwood on the eastern shore of Port Susan Bay. After loading grain on a scow, he would pole it across the shallow shoreline of Port Susan. Shipments of supplies or products depended on the tide until Iverson and neighbor S.J. Barnum built a road (now Sunrise Boulevard) to deliver strawberries to Stanwood.

The 1886 U.S. Coastal and Geodetic Survey and 1911 Department of the Interior maps show the Iverson property as consisting of salt marsh with tidal channels at the base of a steep bank. By 1943, the property was drained and protected by a dike.

Today, Iverson Spit Preserve still contains a pocket estuary, which is a habitat critical for salmon, but the existing estuary is a remnant of the historic estuary that existed prior to diking. Like many estuaries in the early to mid-1900s, Iverson Spit Preserve was diked and drained to support agriculture. It is estimated that between 1870 and 1968, 85 percent of the salt marsh estuary within the Stillaguamish basin was altered to support agriculture.

As the Camano Island farmers and mainland farmers on Port Susan Bay reclaimed the salt marsh for agricultural use, they transformed significant Stillaguamish delta into cultivated land. This exploitation of fertile soils on the tidelands was backed by capital raised through taxes on the lands.

These changes in land use, however, brought environmental losses. By eliminating 85 percent of the tidelands and marshland in Livingston and Port Susan Bays, habitat was compromised for both waterfowl and salmon. Even the hunters on the island noticed. With the loss of habitat and a law that made attracting waterfowl with grain illegal, the island gun clubs dwindled in the 1930s.

As development grew on Camano Island in the 1990s, efforts began to protect the Iverson Spit area. The location's variety of wildlife habitats made it an important area for preservation. The area includes a range of habitat from marine to forest, with the mudflats, marshes and shrubs in between.

Camano Action for a Rural Environment, a citizen group, sponsored several public meetings seeking to protect the area. The consensus to preserve the area was wide, except for the Long Beach community living on Iverson Road. Island County submitted its own application for Conservation Futures funds to purchase the 120-acre Iverson Spit Preserve. In 1999, Island County purchased approximately 120 acres of the Iverson Farm. With the purchase, the county owned cropland, upland forest, estuarine wetland, brackish marsh, upland scrub, 62 acres of tidelands and 3,274 feet of shoreline.

After the acquisition, FOCIP began implementing its commitment of stewardship and trail maintenance by developing a user-friendly trail system. Besides FOCIP's extensive work on the trails, the volunteers have replaced the bridge over the drainage ditch, removed the invasive Scotch Broom, joined with EarthCorps in a revegetation project planting 1,500 native plants along the dike and in reclaimed areas, created the picnic area and installed the informational kiosk.

The site management plan adopted in December 2011 made short- and long-term recommendations. Two of the major concerns included parking that would not create problems for the local residents and protecting the environmental features of the preserve so that the habitat remains viable for wildlife.

Legacy

As development expands on Camano Island and within the Stillaguamish Basin, the Iverson Spit Preserve has become increasingly important to fish and wildlife populations. The 2011 *Iverson Spit Site Management Plan* stated a community vision for the preserve based on public hearings and input:

> *Iverson Preserve is a site where citizens come to enjoy the beauty of the natural environment through limited, low-impact activities while exhibiting stewardship to ensure the health of sensitive ecosystems. Low-impact activities are those activities that do not degrade the surrounding waters, habitats, and vegetation communities and are compatible with the available facilities and surrounding land uses.*

Several studies have explored the potential for restoring a portion of the estuary habitat within the preserve. Anadromous fish (salmon and steelhead and cutthroat trout) from the Stillaguamish River would be expected to use the near-shore and estuarine habitats of Port Susan, Livingston Bay and Iverson Farm. Juvenile salmon samplings from the juvenile chinook salmon rearing in small non-natal streams draining into the Whidbey Basin study by the Skagit River System Cooperative identified coho, chum and cutthroat fry in an unnamed stream near Iverson Spit. This gives some credence to the assumption that the proximity of Iverson to the mouth of the Stillaguamish River would be used if accessible habitat were available.

While the preserve has the potential to provide increased habitat for juvenile salmonids, the local community has expressed concern over the compatibility with existing infrastructure and development. Decisions for increased salmon habitat remain elusive and would require citizen education, understanding and acceptance. The effect on the wildlife currently using the natural preserve would also need to be considered when making changes to habitat. Loss of natural habitat remains a threat for the wildlife relying on the land as well.

In the meantime, the plan indicated that more extensive interpretive signage would aid in understanding what Iverson Spit Preserve is protecting. Signage placed near the various habitats would enrich user experiences and reinforce the values of the preserve. Examples of interpretive signage recommended in the site plan include:

A bench sitting on the dike at Iverson Spit Preserve offers good views of Livingston Bay, mountains and birds. *Author's collection.*

- *actions users can take to protect the fish, wildlife, and their habitats;*
- *the historical perspective of the site: natural estuary to agriculture to preserve;*
- *location and type of sensitive habitats;*
- *farming and floodplains.*

Iverson Spit is a favorite spot for many islanders to peacefully enjoy the day. It might be spent gazing at the trumpeter swans flying across the blue sky with Mount Baker in the background or listening to the call of a loon before it dives for a fish. Maybe it's watching great blue heron stalk their prey in the mudflats or listening to a white-crowned sparrow repeating its song. Sometimes it may be splashing through puddles created from busy beavers or bending low under the crabapple thicket through the Hobbit Trail. Other times it's soaking in the sun while sitting on the beach, enjoying one of those dazzling Pacific Northwest days, totally forgetting the past week's rain. Whatever it is, it's enough to keep Iverson Spit Preserve quiet and ready for the next day of sharing space with the wildlife in its native habitat.

Four Springs Lake Preserve

2001

TODAY

Tucked away in the center of the island, Four Springs Lake Preserve offers visitors a chance to slow down and enjoy the solitude of place—whether that place is the forest, the lake, the wetland marsh or the open pasture. The fifty-acre preserve lends itself to savoring nature and taking in its restfulness.

For visitors coming to walk the trails, a perimeter loop trail of the preserve begins in the picnic area heading south. The trail then turns west and follows a small orchard planted by the previous owners. Once reaching the southwest corner of the property, the trail turns north and becomes a walk through a forest of hemlock, western red cedar, Douglas fir, red alder and big leaf maple. The understory of red elderberry, salmonberry, sword fern with salal and Oregon grape adds to the layering that provides for wildlife in the thirty acres of protected native plants and trees.

This woodland trail crosses a seasonal stream just before it turns east and follows the northern property line. Here the trail will have a few steep climbs and descents, but the territorial view of the forest offers a glimpse of trees at various levels, so it's possible to hear downy, hairy or pileated woodpeckers pounding on snags in the forest and look through the trees to see them at eye level.

Hikers glimpse the lake at Four Springs Lake Preserve from the trail. The vegetative buffer protects the freshwater habitat for wildlife. *Author's collection.*

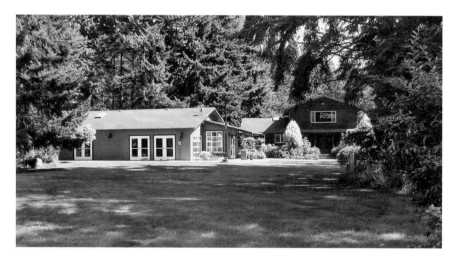

The Meadow Room and Four Springs House provide a pleasant island rental space for weddings and reunions at Four Springs Lake Preserve. *Author's collection.*

Once the trail turns south, the forest grows thicker, as the perimeter property line becomes less evident. While walking down the hill, the lake will come into sight. A cedar fence between the trail and the lake maintains a protective buffer of native plants. The lake is inaccessible along the trail to preserve the native habitat for wildlife. Before leaving the lake area, hikers will see Four Springs House, which does have access to the lake and is available to rent for retreats, weddings, conferences and reunions.

The trail then follows the lowlands of the preserve to the Holton Wetland Interpretive Trail. This portion of the trail has ponds and wetland vegetation. Water levels fluctuate in the seasonal stream. In the spring, skunk cabbage makes the trail both bright with its yellow flowers as well as pungent.

From the wetland trail, hikers reconnect with the western section of the perimeter trail near the stream. A trail spur leads hikers into the pasture area and its native tree groves near the old barn with its corral and old equipment shed that have been restored. The barn also has a heritage display with donated artifacts and equipment from the days of early farming.

The perimeter trail is a 1.7-mile trail with options for shorter loops included within it. The Holton Wetland Trail and the North Loop Trail provide opportunities for people attending a workshop or conference to walk during a break or lunch.

Four Springs Lake Preserve has a serene setting for day conferences and special occasions that is separated from the public trails and picnic area. Rental facilities include the Four Springs House, the Meadow Room, the barn and adjacent outdoor areas. The Four Springs House features a living room with vaulted ceilings and a fireplace, windows overlooking the lake, an open dining area and two smaller meeting rooms. The Four Springs House also has a buffet serving area and kitchen for use by approved caterers. Many brides and grooms have said their wedding vows on the lawn in front of the lake.

The Camano Arts Association displays local artists' work as part of the Art in Public Places program. Artists who participate in this program loan their artwork for an extended period of time. Informational gallery cards aid the viewer's understanding of the work and promote the Camano Arts Association's goal of bringing fine art to the community.

The Meadow Room is suitable for receptions or larger meetings. With an entire wall of floor-to-ceiling windows, the Meadow Room brings in views of the natural surroundings of the preserve. A small kitchenette is available for warming prepared food. The Meadow Room may also be divided into two spaces. The grassy area adjacent to the Meadow Room can be used for outdoor receptions, family reunions or company picnics.

Besides the nature trails with interpretive signs, Four Springs Lake Preserve is a demonstration garden for the Camano Wildlife Habitat Project. Signage along the trail provides information about the grassland, the wetland, the marsh, snags and the natural layering of the forestland with trees, shrubs and ground cover. Plantings around the house also use a mix of native plants and ornamentals that benefit wildlife by providing food, water, shelter and space.

The fifty-acre preserve works as a demonstration garden by showing how a property has various areas that benefit wildlife. Four Springs House and the Meadow Room are in what Washington Department of Fish and Wildlife biologist Russell Link calls Area One. It's an area where people spend a fair amount of time. It's a good place to put a bird feeder and birdbath to learn the birds. Area Two has some use by people but not as steady. Area Three has very little use by people and provides a safe space for wildlife. While Four Springs Lake Preserve has fifty acres to do this, it demonstrates also how people are able to have the three zones in their own properties only on a smaller scale.

Yesterday

"The first time I walked the Natoli property, I became acutely aware of the many mounds, the very uneven terrain in places. Were these earthworks not millennia old glacial-till deposits and the remains of old-growth forest trees; giants that burned, fell, were felled, and decayed resulting in the lumpy ground underfoot?" wrote Patricia Nash in her history of Four Springs Lake Preserve for the acquisition application.

Located in the center of Camano Island, Four Springs Lake Preserve is a fifty-acre preserve that reflects the island's agricultural heritage and past use during the settlement of Camano Island. Scarred logs and stumps also show the remains of a fire that roared through in the mid-nineteenth century and another fire caused by lightning between 1910 and 1912 that left debris and large stumps smoldering. The fires, along with the decomposing of the giant logs of Douglas fir, western red cedar and western hemlock, created rich soil that attracted immigrant farmers and families.

The Four Springs Lake Preserve property was originally part of a larger homestead parcel. Eventually, Al Smith bought forty acres of the homestead. Living in Seattle, he used the property on weekends and stayed in the one-room house. The parcel also included an old barn built in the early twentieth

century during the logging years to house the draft horses, according to former owners Royce and Rhea Natoli.

In 1944, E.H. "Bud" and Catherine Jamison purchased Smith's forty acres and spent weekends on the property. After adding two rooms in 1948, they moved into the old house. Jamison worked at the Camano City sawmill, while Mrs. Jamison gardened, canned most of their food and raised and bred canaries. The Jamisons not only lived off the land but also found pleasure from its waters. Four springs ran through the property, and Jamison created a small dike to provide a pond for his children's boats. Later, the son, Bud Jr., acquired a few head of cattle for a Future Farmers of America project. Despite lacking a well or electricity, the Jamisons began excavating to build a larger house. (The excavation site is still visible near the corral by the restored barn.) After attempts at drilling for a water source failed, they moved back to Seattle. They sold the land in 1952 to Henning Sandberg.

To create a better source of water for cattle, Sandberg's son Albert reinforced and enlarged the dike across the west end of the pond. With a herd of fifty-five cattle, the forty-acre farm qualified as open space agriculture. A few additional dairy cows supplied Albert and his wife, Nelda, and some neighbors with milk.

Royce and Rhea Natoli purchased the Sandbergs' forty acres in 1977. For the next thirteen years, the Natolis spent weekends and vacations on the land, making improvements by clearing fallen trees and debris, as well as fortifying and expanding the pond. When they retired in 1990, they moved to the property and really started to work by removing logs and invasive weeds from the pond, reseeding the pasture, drilling a well and building a house. Royce also dismantled the old house and recycled the wood into a small barn. In 1993, the Natolis purchased an adjacent ten acres of a former strawberry farm.

By the fall of 1998, the Natolis had decided to sell a ten-acre parcel of their property. Karen Kelly, member of Friends of Camano Island Parks, answered the advertisement in the *Stanwood/Camano News*. While walking the trails on the property, she appreciated the serenity and beauty of the entire fifty acres. Thinking the land was too special to divide into five ten-acre parcels with a home on each one, Kelly talked to the Natolis about the Island County Conservation Futures Fund Program, a county tax dedicated to the purchase of land meeting certain conservation criteria.

Not long afterward, in October 1998, Kelly, along with FOCIP co-chairs Carol Triplett and Pam Pritzl, met with the Natolis to discuss the Conservation Futures Fund program criteria and FOCIP's willingness to

sponsor preserving the Natoli property if the Natolis wanted to sell the entire fifty acres. In November 1998, Royce and Rhea sent a letter to FOCIP supporting the organization's sponsorship of a Conservation Futures Fund project. "We feel this property is unique and would like to see it preserved and maintained for future generations to enjoy as we have," wrote Royce and Rhea Natoli in their letter.

Shortly before the Conservation Futures Fund application deadline in the spring of 1999, the county informed FOCIP that the county didn't have funds available for the purchase during the 1999 application cycle. The county also stressed that the funding was available only for land purchases and could not be used for the modern buildings on the property. To emphasize the conservation-worthy aspects of the property, Pritzl brought in local Audubon and Washington Native Plant Society representatives to assess the habitat value and support the acquisition.

Despite these obstacles, FOCIP submitted the application and also committed to raising nearly $300,000 to purchase the house on the land to use as a day-use retreat/conference center. After the county's technical advisory committee determined the property met the conservation criteria, the citizen advisory board recommended purchase of the property after a public meeting attended by seventy-five citizens. Once the county commissioners approved the project funds for the land, FOCIP dedicated time and money for formal packets, mailings, pledge forms, presentations, talks, tours and newspaper articles to purchase the house.

Dave Pinkham, publisher of the *Stanwood/Camano News*, wrote in his August 22, 2000 staff editorial:

> *People often ask what they can do to help save some green, publicly-accessible space, while conserving a local ecosystem, on an island that is rapidly developing. This is the most important thing people can do: give to a public-private partnership to make a project like this succeed before it is too late. The day will come, in the not-so-distant future, when the opportunities like this to improve the quality of island life will no longer exist. The landowner prefers not to subdivide, nor sell to a future subdivider. The county is willing and able to participate. Caring volunteers are doing the legwork. All they need is help from donors.*

One area family, who remained anonymous, pledged $88,000 at the beginning of the fundraising campaign to start the funding. "This lovely piece of land is a real treasure; I believe that we must take charge of our own

environmental future by preserving native ecosystems wherever possible," said the donor. "It is to everyone's benefit to have open land, accessible by the public."

Between the summer of 2000 and the spring of 2001, FOCIP raised funds to purchase the building portion of the property. Donors contributed $224,000 to purchase the house and outbuildings. Ginny Sharp, a FOCIP volunteer, played a significant role in developing the fundraising materials that were distributed. There was immense community support, with pledges as small as $5 and up to $88,000.

On April 18, 2001, the sale was completed with the Natolis. The first event at Four Springs House was a donor celebration on May 6, 2001, with tours, food, music and congratulatory speeches for the one hundred people attending.

"With the increasing pressure to log and build on Camano Island, it is imperative that we save natural environment for all to enjoy," said Carol Triplett. "To preserve this beautiful area in the heart of the island will help keep a balance between development and the natural beauty that attracted residents in the first place."

Triplett also stressed that the project was sponsored by FOCIP for the Camano Island community. The county commissioners congratulated the donors for making a difference in the community by contributing to the purchase of the fifty-acre parcel for a wonderful preserve. Royce and Rhea Natoli were recognized for their preservation and caretaking of the land to maintain the native vegetation and wildlife during their years of ownership and making it available for preserving.

After the donor celebration, it would take another three years to open the park's trails in November 2004. Reservations for Four Springs House and the Meadow Room began in March 2005. Between the date of the purchase and the opening, the county renovated the house for conference use and converted the garage into the Meadow Room. The Four Springs Lake Preserve Advisory Committee, under the direction of Island County Parks and Recreation, developed guidelines and a mission to create a day-use park and retreat/conference center. The committee used the $12,000 donated matching funds that arrived after the acquisition to purchase appropriate furnishings for the house as a conference center.

Other FOCIP volunteers worked on the trail system and, by opening day, had improved trails, purchased signage and marked the trails on the property. FOCIP volunteers continued to work on the grounds,

FOCIP volunteers restored the old barn roof at Four Springs Lake Preserve to showcase the island's farming history. *Author's collection.*

building cedar fencing along the lake and around the rental facility. Trail maintenance and improvement has been a continuing task. The organization also restored the barn and created a display of the island's farming history.

Habitat Stewards and FOCIP volunteers helped the Camano Wildlife Habitat Project create a demonstration garden at Four Springs Lake Preserve that provides food, water, shelter and places to raise young around the house, in addition to the natural land throughout the fifty-acre preserve. In August 2005, the National Wildlife Federation certified Camano Island as a Community Wildlife Habitat during a celebration held at Four Springs.

"Four Springs Lake Preserve is an inspiring example of the good that happens when community residents work together for the benefit of everyone," said Terry Arnold, superintendent of Island County Parks, at the November 6, 2004 open house and special celebration opening the preserve to the public.

LEGACY

"Everyone here should smile a little smile of satisfaction that persistence paid off and we have added to the quality of the island and quality of life for its residents and visitors," said Ginny Sharp, FOCIP volunteer, at the February 23, 2010 recognition program honoring the Natolis with a newly installed plaque for the property.

Because of the volunteers, the donors and the willingness of the Natolis to work with them to preserve Four Springs Lake Preserve, a fifty-acre forested parcel with its lake, wetland, pasture and homestead remains in its natural state as a refuge and retreat for the community and a protected corridor for the wildlife. Beyond that, the property also protects centrally located stream flow and water quality by preserving the ecosystem of the forest of coniferous and deciduous trees, the lake and wetland ravine and the buffer of trees and wetland plants along the north and south shoreline of the lake.

The lake with its wetland plants and the adjacent wetland in the ravine are part of a major drainage system on the northwest ridge of Camano Island that is connected with Carp Lake and with an outlet stream that eventually flows to Saratoga Passage. The fifty acres left as natural space preserve wildlife habitat and a natural corridor, including lake, wetlands and forest with native trees and vegetation. The area still flourishes with typical woodland and wetland native plants with no extensive invasions.

Four Springs Lake Preserve lies midway between four public lands: Camano Ridge Forest Preserve, Elger Bay Preserve, Cama Beach State Park and Camano Island State Park. Trail connections to and from this property would establish the Island County Non-Motorized Trails Plan proposal for a ridge trail the length of the island.

Future use of the house and meeting room will achieve the initial vision of Four Springs Lake Preserve as a retreat center. Developing partnerships with community arts, religious, youth, social and cultural organizations to create programs and interpretive field trips, links with the schools and traditional and seasonal celebrations would activate the cultural and environmental educational learning opportunities the Four Springs Lakes Preserve setting provides.

"Marketing funds for the facility is a continual need. FOCIP originally committed $1,000 to seed the marketing needed for the facility to be successful. We think it is an asset to the island and will become more successful each year," wrote Carol Triplett in a history of the acquisition report.

Creating Four Springs Lake Preserve as a preserve in the middle of the island that could have become five homes with acreage is a noteworthy citizen achievement. Because one person who saw an advertisement for a future home site talked to the landowners about a different option and connected with a volunteer group, Friends of Camano Island Parks, the community now has a nature preserve on the island with an education/retreat center. At more than one point, success looked bleak due to lack of Conservation Futures funds and having a modern house on the property. However, FOCIP members have consistently shown their "why not" mindset and bothered to pursue a way to protect the land.

Triplett said during the promotion of the acquisition:

> *Economic pressure on Camano Island residents to sell timber and change zoning for housing development is increasing at an unprecedented rate. As the island becomes more heavily populated, we must plan ahead to meet the demand for open space and a trail-linked system of parks…Only when our community has pushed for it, have public lands been made available. That* [Camano Island State Park] *was the beginning of cooperative efforts to benefit our community. Not much has changed since then. Camano remains an attractive place to live. And, we still have to take the initiative to acquire and preserve natural areas for the public to enjoy.*

Thanks to the coordination of volunteers, the landowners and the county, Four Springs Lake Preserve provides a place for families, friends or workshop participants to gather to celebrate or learn near the rental facilities. At the same time, casual visitors can still wander in the peacefulness of the forest, the wetland marsh or the open pasture of the preserve. Meanwhile, the creatures of the wild thrive in their Area Three space a bit away from the celebration but close enough for a nature walk view.

Elger Bay Preserve

2001

Today

Elger Bay Preserve, located on both sides of Elger Bay Road toward the south end of Camano Island, has trails that offer not only pleasant forest walking but also outdoor learning opportunities, especially about beavers and native plants. At the trailhead on Dry Lake Road, walk north in the West Forest Section roadside forest before crossing Elger Bay Road. This trail bends west through the woods before heading east toward Elger Bay Road. Carefully cross the county road to access the main trails on the east side. Note: the fifty-miles-per-hour speed limit means alert walking is mandatory when crossing the road.

The approximately 2.5 miles of maintained trails offer various options. The 2.2-mile loop trail includes a walk through the forest with opportunities to hike through forested land, learn about native plants on an interpretive trail and take a detour to a beaver marsh.

Directional signs take a hiker along a trail that serpentines through the forest and intersects an old logging road before connecting with the interpretive nature trail. Icons on plant identification signs assist with learning about each plant's uses. A tree indicates the plant was used by Native Americans, a bird indicates the plant is a food source for birds and a circle with a slash through it indicates it's a nonnative invasive plant. The interpretive trail is

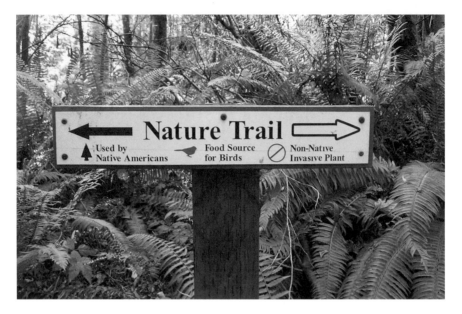

The Nature Trail at Elger Bay Preserve is a one-mile loop interpretive trail with identification signs designed for the nearby school's students. *Author's collection.*

one mile and can be more directly accessed from the Elger Bay Elementary School parking lot on weekends.

A side trail off the nature trail leads to a kiosk and viewing platform of the beaver marsh. The glacier that once covered Camano Island left the shallow depression that collects water. After the logging in the 1980s, beavers built a dam near the east side of the marsh and raised the water level. Water flows from the marsh through a seasonal stream to Port Susan Bay. The debris from the marsh nourishes the salmon, forage fish and crab that inhabit the shoreline habitats.

The viewing platform allows nature walkers to watch and listen while visiting habitat for amphibians, reptiles, birds and mammals. While lingering at the marsh, bird-watchers can witness the natural world as great blue herons stalk their prey and belted kingfishers chatter before hovering and diving for their fish. Meanwhile, bald eagle, red-tailed hawk and osprey roost in trees, waiting for their prey. In addition to the red-winged blackbirds sitting on perches and belting out their *conk-la-ree*, ducks and songbirds forage and nest in the marsh vegetation.

Returning to the nature trail, at the 1.1-mile post, the South Hill Section loop begins a climb with views of the forest. While it's a moderate climb,

looking down on the forest and its understory offers a sweeping view of the forest that's very nice and very different from the usual island water views. The trail continues until reaching the crest where the bluff overlooks the Elger Bay Elementary School. While walking the bluff, the trail takes walkers through a thicket and by an amphitheater used by the students as an outdoor classroom. Stick to the right on the trail to continue walking in the preserve rather than the trail heading down to the school.

The South Hill Section trail rejoins the interpretive trail and leads to the educational kiosk, which is the start of the trail for the students. This trail will take walkers to the Elger Bay Road crossing south of Dry Lake Road, and then a short trail through the West Forest Section returns to Dry Lake Road.

The Elger Bay Preserve trails connect with Cama Beach and Camano Island State Parks by walking 1.4 miles west along Dry Lake Road to the Cross Island Trail access to Cama Beach State Park. Dry Lake Road is a local road with little traffic. The Cross Island Trail is at the end of Ivy Way at the Dry Lake Road Trailhead.

YESTERDAY

Elger Bay Preserve used to be a forest managed by the Department of Natural Resources (DNR). In 2001, the state transferred the forested land to the county in a thirty-year lease. Prior to this non-fee lease, the land supported state school districts with the DNR controlling and managing the two hundred acres of public school trust land. Throughout the years, the land had been clear-cut and the trees harvested, with the profits aiding school districts in the state.

However, the real estate market value for raw land changed the dynamics of forested land on the island. Development resulted in large clear-cuts without planned forest management. During a March 1994 planning commission meeting, some citizens wanted tougher restrictions for clearing land on Camano. Others saw value in the timber sales. Management of the forests for timber and maintaining forestry as a self-sustaining local industry on Camano Island was threatened by intense development.

Opposing viewpoints of the role of forestland created a dilemma, and the Island County planning commission recognized the need to resolve the conflicting goals of maintaining environmental standards with protecting one of the traditional industries of Washington. Planning commissioners

also stated that the lack of planned forest management had created problems, which included abnormal water runoff and soil erosion within watershed basins, depletion of wildlife habitat and a loss of dominant seed-bearing trees within forested areas.

To enhance the economic viability and protect forestry as a way of life on the island, the planning commission urged the county to preserve and encourage rural forestry operations. It also sought coordinated planning with state agencies. Seeing that the Elger Bay DNR trust land no longer performed as a profitable working forest, Island County commissioner Dwain Colby and the state DNR tried to identify alternatives to clear-cutting the state forestry land at Elger Bay Road.

Alternatives for the Elger Bay DNR land became apparent in April 1995 when the Island County Board of Commissioners adopted the Island County Non-Motorized Trails Plan. Included in this trails plan was the vision of expanding the park system through connections by using access routes on the public tidelands and the state forestlands. In the plan, the Elger Bay DNR land's location placed it in a corridor that could link it with the state parks by using Dry Lake Road.

Friends of Camano Island Parks formed the Camano Island Non-Motorized Trails Committee following the Island County public hearings on the plan because of the public's interest in trails. The FOCIP trails committee began investigating the trails proposed in the plan, with an emphasis on actually implementing the plan and connecting public lands with trails. The committee also began exploring ways of shifting the DNR landownership by promoting the Elger Bay DNR and Carp Lake DNR (Camano Ridge Forest Preserve) lands as priority parcels for the Trust Land Transfer Program. This program transfers ownership of state forests that are more suitable for natural or wildlife areas, parks, recreation or open space.

The idea of corridors on the island was not a new one. A citizen's letter in the *Camano Island Sun* during the 1980s urged island planning for corridors. When the county's plan created the trails' vision, the FOCIP committee took those ideas as a directive for action.

After the plan came out, interest in trails in the DNR land escalated. During a Camano Community Council meeting in the fall of 1995, Jennifer Belcher, commissioner of public lands, said selling or trading DNR land to other public agencies or conservation agencies was unlikely because of little funding and limited resources for park or trail projects. However, it could be sold to developers to benefit the trust. "If the county zones everything around for development, then it doesn't make sense [to continue harvesting

parcels]. The property would [then] be more valuable developed," according to Belcher.

Belcher also emphasized that the DNR avoided doing large clear-cuts on the Elger Bay DNR parcel and replanted immediately to avoid runoff. The department recognized that the forestland contributed to the island's water recharge system. Belcher indicated that trails would be possible on the parcel but cautioned not to rely on continued availability. "If we harvest, we don't plan to clear cut all at once. We don't discourage trails as long as we can harvest timber," Belcher said. "As long as everyone remembers the primary use is timber harvest. The trail may disappear. We work with recreation groups to protect wetlands and identify where recreation is OK. It's not a park, but would provide some recreational opportunities."

FOCIP began building trails, restoring old trails and maintaining trails within the Elger Bay DNR land in 1995. After creating a loop system of trails, including signage within the parcel, FOCIP started guiding community walks. The group adjusted the trail system when the Elger Bay Elementary School was built in 1999 on twenty acres of the property. The school district fenced the school facility and playfields from some of the existing trail on the forested portion of its twenty acres and saved trees surrounding the trail portion. FOCIP was given permission from school district personnel at the time to include the upper portion (where the outdoor amphitheater is) as part of the overall Elger Bay loop trail route.

Don Hanna, chairing FOCIP's trails committee, worked with the community, the Nature Conservancy and DNR to have both the south and north DNR lands become part of the Trust Land Transfer Program. This would preserve the parcels and make them accessible for public use. While Hanna spearheaded a letter-writing campaign to have the Camano lands transferred, FOCIP hosted winter walks and encouraged citizen walkers to write letters, e-mail and call legislators to support a transfer.

From 1996 to 2003, FOCIP members continued writing letters and meeting with legislators to try to persuade the DNR to place Elger Bay and Carp Lake DNR parcels on the Trust Land Transfer Program priority list. In 1999, the state legislature created the thirty-year lease option for some parcels where the state appropriation paid the lease, and the trust retained the ownership. Elger Bay was twenty-first on the priority list during the 1997 to 1999 biennium. In 2001, the state legislature agreed to transfer the parcel to Island County with a non-fee thirty-year lease option. Local legislators' support assisted in promoting this opportunity for Island County to receive the Elger Bay DNR parcel as public land for conservation and recreation.

The Washington State 1997–99 Trust Land Transfer Program Summary recognized the strong local community support for a transfer:

Benefits to Trust:
This Camano Island property is difficult to manage for income production due to an organized, vocal demand for protection of the site by islanders. Even minimal harvesting proposals are rigorously opposed. The property is surrounded by residential uses. It is extremely accessible, being divided in two parts by a county road and is heavily used for recreational bicycling and hiking. The Camano Island Non-Motorized Trails Steering Committee has included this parcel as an important part of an island trail system that connects this parcel to the Camano Island State Park.

Features of Significance:
Protection of the forested property is considered to be a necessary and significant part of Camano Island's open space and trails plans. The property includes a significant number of wetlands, including one wetland over twelve acres in size. The property is considered critical for protection of island wildlife. The parcel was also recognized in Island County's Comprehensive Non-Motorized Trail Plan as a proposed link in the county's trail system.

Government support of the community's desire for an improved trail system and a protected forested/wetland area and wildlife corridor addressed the difficulty of managing a working forest on land straddling both sides of Elger Bay Road and surrounded by residences. Transferring the forest parcel with the wetlands preserved a critical area for island wildlife. While preserving timbered and natural lands, the transfer also protected necessary space for animal corridors lost in other areas throughout the island because of ongoing development.

LEGACY

Transferring the Elger Bay DNR parcel extends beyond preserving the natural land from development and maintaining corridors; it also provides an outdoor classroom for students in the community. In a world where Nature Deficit Disorder has been identified as a separation between both

The Elger Bay Elementary School students added signage to the Nature Trail at Elger Bay Preserve, which serves as an outdoor classroom. *Author's collection.*

children and adults from nature, connecting kids with nature has become a goal. The Elger Bay Preserve is adjacent to the Elger Bay Elementary School, and the students use it during the school day, especially for science and physical education classes.

During 2004 and 2005, the Camano Wildlife Habitat Project, sponsored by FOCIP and supported by the National Wildlife Federation, created a signed nature trail in the preserve. FOCIP volunteers cleared and built the nature trail. Boy Scouts completed an Eagle Scout project to install plant identification signage on the trail under the guidance of Habitat Steward LaLee Burrill. To create signs for the students to understand the uses of the plants both by wildlife and Native Americans, Burrill worked with teachers at the school. The kiosk for the trail is near the elementary school parking lot and serves as an entry point for the students to enter their outdoor classroom.

The National Wildlife Federation certified the Elger Bay Elementary School as a Schoolyard Habitat in 2005. Besides having a schoolyard providing the basic essentials of food, water, shelter and places to raise young for wildlife, the teachers attended outdoor education training by the National Wildlife

Federation. With the Elger Bay Preserve adjacent to the school, the teachers use the nature trail, beaver marsh platform and amphitheater as extensions of the classroom. The students visit and learn about the local wildlife, their habitats and the native plant life. FOCIP volunteers donated the signs, built the kiosks and beaver marsh platform and continue to maintain the trails.

The students also take their learning seriously and understand the dire effects of pet waste on the trails and near the beaver marsh, which drains into Port Susan Bay in Puget Sound. They've put up their own signage about pet waste. Dog owners take heed.

Freedom Park

2002

TODAY

Freedom Park represents the spirit of the Camano Island residents and their willingness to see a way to make things happen. While the park is dedicated to the Pearl Harbor survivors and their protection of our freedom, it also represents the free spirits on the island who saw a way to squeeze a park out of a development.

The park's plants, sculptures, memorial plaque, ship's bell and playground give Terry's Corner the rural character essence that a Camano Gateway needs. Located in between East Camano Drive and North Camano Drive at the Y junction at Terry's Corner, access to parking is on North Camano Drive.

Walk on grass or woodchip pathways throughout the grounds to view the artwork created by local artists. Educational signage on the pathways encourages adults and children to communicate and move around while enjoying the outdoors with a variety of specific activities for each stop. The memorial plaque and ship's bell dedicated to the Pearl Harbor survivors are respectful as well as child friendly. Children especially love the playground that includes a Viking ship, swings, slides, climbing ropes, monkey bars and a tire swing. Suggestions made by Camano Island children helped to design the community-built playground.

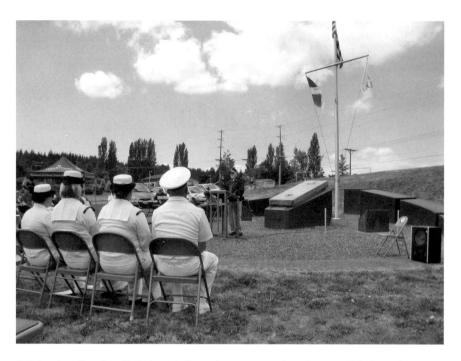

Phil Lewis, a Freedom Park Association volunteer, organizes the annual Independence Day program at Freedom Park, which is dedicated to survivors of Pearl Harbor. *Author's collection.*

Freedom Park Association manages the park, which was built completely from donated time and materials. The nonprofit association was established to take over park ownership from the nonprofit group, Camano Action for a Rural Environment, that received the land donation for the park.

On Independence Day, a public program is held to honor all those serving or who have served our country to maintain our freedom. At times, there is a public program to honor the Pearl Harbor survivors on December 7. This used to be held at the Terry's Corner Fire Station across from the park.

The island's park and ride is adjacent to Freedom Park. The free public transit takes riders around the island and to Stanwood. Island Transit also has county connector buses for commuting to Mount Vernon and beyond. A small shopping area adjacent to the park and ride includes the library, shops with local goods, a visitors' center and a seasonal art gallery.

YESTERDAY

Freedom Park's location near Terry's Corner was first known as McEachern's Corner after Dr. McEachern, a pioneer Stanwood doctor. In 1912, McEachern bought forty acres of farmland, which included the land where Freedom Park now sits. To the south, the area that is now farm fields was bottomland that sloped and drained into Livingston Bay.

After the Terry family bought the McEachern farm, the area became known as Terry's Corner, which was considered the intersection of North Camano Drive and Sunrise Boulevard. Will Terry planted wheat and hay on the hillside farm west of the current Sunrise Boulevard.

In 1973, the *Stanwood News* announced the proposed Y interchange to adjust the Terry's Corner intersection. The fork interchange was eventually built where State Highway 532 ends and East Camano Drive and North Camano Drive begin. The Camano Island Chamber of Commerce provided a directory with a printed map at the new intersection. Later, a visitors' center and garden with artwork were added to this Camano Gateway.

Through the years, the triangle of land between East Camano Drive, North Camano Drive and Sunrise Boulevard had been eyed with different views of what a gateway to the island should look like. For some, the blackberry brambles were fine; for others, a shopping center seemed to fill a need.

In 1976, Camano developers Stan Starkenburg and Hap Schnase proposed a shopping center and were issued health and building permits. Site preparation began for forty-one thousand square feet of retail space that would include a grocery, pharmacy and eight other stores and shops. Mel Preston, Whidbey Bank manager, said that intent-to-rent statements had been received from half the potential occupants. The newspaper stated construction was slated to begin that summer. However, in April 1989, Schnase sold the acreage at Terry's Corner to Bellingham-based Consumers Choice, Inc. grocery chain to build an island store. That new store was scheduled for a 1990 opening. In 1994, another proposed mall failed, and the land was for sale again.

Three years later, David Platter made an attempt to develop the property into a shopping area with a motel. This effort activated many Camano citizens to stop the project. Concerned that a strip mall would be inconsistent with the rural character of Camano Island, forty-three people attended a citizen meeting on September 5, 1997, at the Camano Multipurpose Center. (This blue building on East Camano Drive used to be the senior center and

has become a meeting center for many citizen groups.) After a series of meetings, they formed a nonprofit land preservation group, Camano Action for a Rural Environment (CARE).

The Island County hearing examiner approved the developer's plan for nineteen businesses on the 11.3 acres of Terry's Corner, stating that the development did not violate existing laws as long as the developers met the conditions related to drainage, water availability, traffic impact and landscaping. CARE appealed that decision. The group called the county out of compliance with state law for not revising the comprehensive plan for growth management and also for making decisions on urban and commercial uses that didn't even comply with the existing 1984 comprehensive plan.

The biggest issue for the citizen members of CARE was how the project would violate sections of the growth plan that require compatibility with the character of the surrounding uses and preservation of scenic corridors. Other concerns included saltwater intrusion, oil or gas spills, storm water runoff affecting Port Susan Bay and the impact of increased traffic.

After CARE researchers discovered errors and misstatements by the planning department staff, the Island County commissioners ruled that the car wash and fast-food outlet would not be allowed, the motel would need to be downsized and provisions for water and sewage would have to be made. Platter never responded to the new requirements, and after two years, his option to buy the land from the owners, Brown and Cole, expired.

In February 1999, CARE member and real estate agent Mike Nestor received a call from Brown and Cole to let him know Platter's option to buy had expired. Nestor called a group of community leaders to meet with Jim Anderson of Brown and Cole. Local artist Jack Gunter asked if the two lots composing eight acres were sold at market price, would Brown and Cole give CARE the other three acres for a park. They would, and they did.

Eventually, a small shopping area with a courtyard and the library was created on one of the parcels and a park and ride for Island Transit on the other. The additional three acres were donated to CARE on December 7, 2002, to be set aside as a park dedicated to the survivors of Pearl Harbor. "We want to preserve it for all of our community. We acknowledge this property as a generous gift from Brown and Cole and plan to treasure it now and for future generations," wrote Joyce Christianson, a CARE board member.

CARE transferred the property to Freedom Park Association, a nonprofit organization formed to manage the park. Native plants were planted, an old ship's bell was installed and a memorial plaque was dedicated to the Pearl

Freedom Park at Terry's Corner remains an open space gateway to Camano Island. *Author's collection.*

Harbor survivors. Along with outdoor sculptures and art, education signage was added throughout the park for adults with children to walk around and try various activities.

In 2010, at the east end of Freedom Park near the Camano Gateway map, volunteers built a ten-thousand-square-foot Rotary Adventure Playground in five days. This happened with the planning, fundraising and coordinating of many volunteers. Using funds raised from the Rotary Club, local companies and community members, the playground filled a need. Children now have a place to play. Other than small playgrounds near the ball field at the Camano Multipurpose Center and the two elementary schools, there was nowhere else to play.

LEGACY

Although Freedom Park is owned by the Freedom Park Association, it is definitely a community park. Community spirit created both the opportunity for the park and the park itself. Freedom Park also continues because of

this community spirit. All the maintenance for the park is through volunteer efforts, and the upkeep for the park is through public donation.

The volunteers keeping this public gateway open do so with a devoted commitment. Mike Nestor continues to find volunteers to help with the maintenance. Phil Lewis continues to organize the programs to honor the veterans and current military members. To fund the park's needs, artists Jack Gunter and John Ebner donate art at the annual Camano Island Chili Chowder Cook-Off to raise funds for Freedom Park.

Thanks to the volunteer vigilance and dedication of CARE and the Freedom Park Association, the Camano Gateway at Terry's Corner maintains the rural character an island paradise deserves.

Camano Ridge Forest Preserve

2003

TODAY

While walking through and around the Camano Ridge Forest Preserve, hikers can lose themselves in the forest—both literally with its various loops and figuratively while gazing toward the tops of the Douglas firs and western red cedar or looking down at the moss on the fallen logs and stumps. Seeing green is the focus on a walk through this forest, especially with the abundance of sword ferns, Oregon grape, salal and native plants covering the forest floor and providing habitat for the island's wildlife.

Stopping and listening provides an opportunity to hear what's happening. On a foggy day, it could be falling dewdrops. A little later, it could be a Pacific wren singing one of its long melodies. After a while, a tree frog may croak from somewhere nearby, but just try to find it. Not to leave out the other senses, the smells of the forest come alive, whether they're reminding us of Christmas because of the scent from a fallen limb or we're scrunching our noses near the wetland because of the skunk cabbage. The deep crevices on the Douglas fir trees await a hand to feel the bark's ridges. However, the new growth at the ends of the grand fir fronds awaits a gentler touch. Then there are the berries—plenty of berries. Some will be quite tasty, like the blackberry, thimbleberry and salmonberry, while others are okay to leave for the critters, like the

Camano Ridge Forest Preserve is popular for hiking and important for aquifer recharge and wildlife habitat. *Robert N. Cash.*

snowberries that last through the winter, waiting for whoever needs to eat on a cold January day.

This preserve, once a Department of Natural Resources working forest, is one of the last large and intact forests left on Camano Island. Much of the approximately four-hundred-acre preserve is alder and scrub brush with some clear areas. Another area has trees thirty to forty years old with less dense understory. Even though the trees look big in areas of the forest, it is third growth.

Parking access for hikers is from the trailhead at Can Ku Road on the east side of the preserve. This is a steep trail with switchbacks and blind curves. It connects with the former logging roads and trails in the main acreage's higher elevation. Access for mountain bikers is by a closed-to-vehicles access road approximately a quarter mile from Camano Ridge Road on the west side of the preserve.

While hiking, look for trail markers indicating the best route. Trails crisscross throughout the property. The East to West Center trail is a wider trail that connects both east and west access trails to the preserve. The South Primitive Wetland Trail is a more rustic alternative to the Center Trail. The

East Forest Loop Trail follows the perimeter of the forested section of the preserve. It's a 2.3-mile round trip from the Can Ku Road trailhead. The West Forest Loop joins the east loop at the north end and is a narrower, more primitive trail that can extend the walk. The East and West loops combined are 3.2 miles from the Can Ku Road trailhead.

Camano Ridge Forest Preserve is not a well-known hiking area outside the island and is not heavily used. Note: hunting is allowed in the preserve. Watch for hunting regulation signs during the fall.

Yesterday

Camano Ridge Forest Preserve is the largest acreage preserved on the north end of Camano Island. Prior to 2003, this DNR parcel was known as the Carp Lake DNR land. The forestland supported state school districts, with the DNR controlling and managing more than four hundred acres of it as public school trust land. Over the years, the parcel has been clear-cut and the trees harvested, with the profits aiding school districts in the state.

The Island County Board of Commissioners adopted the Island County Non-Motorized Trails Plan on April 24, 1995. In the plan, the Carp Lake DNR land's north central location placed it in corridors to the state parks to the south and to Port Susan Bay to the east, with trails through the property to provide these connections.

Once Friends of Camano Island Parks formed the Camano Island Non-Motorized Trails Committee, the committee began exploring trail options proposed in the plan. The committee also began advocating shifting the Elger Bay DNR and Carp Lake DNR (Camano Ridge Forest Preserve) lands to protected preserves through the Trust Land Transfer Program.

The Department of Natural Resources manages more than 5.6 million acres of state-owned forest, range, commercial, agricultural, conservation and aquatic lands, with more than half of these lands held in trust to produce income to support public schools and other state institutions. Because of limited potential for growing timber, not all the land provides suitable income production; however, the land may have significant ecological or recreational qualities that benefit the public.

In 1989, the legislature developed the Trust Land Transfer Program to add money to trust beneficiary accounts, to protect properties with significant

natural and recreational value and to better manage trust properties for income production. The transfer program does this by:

- *transferring ownership of trust lands that are more suitable for natural or wildlife areas, parks, recreation or open space;*
- *providing revenue to trust beneficiaries such as schools, districts and universities by depositing timber or lease value of transferred parcels into a beneficiary account; and*
- *providing alternative parcels by using the land value of the transferred property to purchase replacement trust land with better income potential.*

The DNR properties selected for transfer are determined by ecological attributes (riparian, wetland, habitat), local impacts (population growth), recreational opportunities and scenic or natural features.

Review committees rate a land parcel's timber to land value and create a prioritized list that is reviewed by the commissioner of public lands and approved by the Board of Natural Resources. This list is submitted with a funding request to the governor and legislature. The legislatively approved and funded parcels are appraised and presented to the Board of Natural Resources for its approval. Once the board approves the transfer, the value of timber or lease is deposited in a land replacement account. The trust land is transferred to the receiving agency (such as Island County for the Camano Ridge Forest Preserve), and the DNR finds a suitable alternative property, which is purchased with funds from the land replacement account.

Prior to FOCIP involvement in the Carp Lake DNR land, illegal dumpers and campers used the area. It also suffered from abuse by ATVs and motorcycles using the logging roads in the parcel. In 1996, an agreement between the DNR and FOCIP's trails committee allowed the group to build a trail through the two-lot access from Can Ku Road to the main parcel of DNR land. With the DNR permits, FOCIP built a walking trail and did extensive cleaning of the area. Besides work parties clearing, brushing and monitoring trails, FOCIP guided regular nature walks to introduce people to the land.

Each year during the 1996 to 2003 legislative sessions, FOCIP encouraged members and Camano Island citizens to write letters and meet with legislators requesting placement of the Elger Bay and Carp Lake DNR lands in the Trust Land Transfer Program. The group also encouraged citizen walkers to write letters of support. Local legislators

Walk the forested trails without interruptions at Camano Ridge Forest Preserve. *Robert N. Cash.*

assisted in moving the parcels into a priority position for a transfer. In 2003, the Whidbey Camano Land Trust worked directly with the state to ensure the property was permanently transferred in fee ownership rather than with a thirty-year lease agreement.

The state publication listing priority transfer properties took note of both citizen involvement and Camano Ridge Forest Preserve's location:

> *Trust Benefits*
>
> *This property is difficult to manage for income production due to its location on a popular island that is a tourist destination point and because it is surrounded by residential use. It is recognized as important, undeveloped property on the north end of Camano Island where the need for more open space, trail areas and wildlife habitat are in high demand.*
>
> *Features of Significance*
>
> *The property is located on the north end of Camano Island. It is one of the largest undeveloped parcels on Camano Island and is one of the only such areas located on the north part of the island. Development and heavy use by the public for dispersed recreation has created high pressure for trail*

construction. The parcel is also recognized in Island County's Comprehensive Non-Motorized Trail plan as a proposed link in the county's trail system.

Prior to the transfer, the DNR would not allow FOCIP to expand the trail system and required FOCIP to be discreet when advertising the trails. Once ownership transferred to Island County in 2003, FOCIP expanded the trail system and worked with Island County Outdoor Recreational Enthusiast, a mountain bike volunteer group, to establish environmentally friendly, non-motorized trails for the area. The two groups coordinated to develop an overall plan to create trails with conservation aspects of land maintained and the overall protection of the land considered.

The area became the Camano Ridge Forest Preserve to indicate its location near Camano Ridge Road. The name also recognizes the preservation of the forest.

Legacy

Island residents and visitors gain much from the protection of Camano Ridge Forest Preserve: public access and trails, wildlife habitat, watershed protection and a beautiful, undivided forest for future generations. The site is popular for hiking and important for aquifer recharge and wildlife habitat.

At some point, there may be a formal entrance with parking access from Camano Ridge Road. The area is currently under the jurisdiction of the Island County Public Works Department. This jurisdiction allows for deer hunting in the preserve. Public hearings have indicated the unrest adjacent landowners feel about the hunting being close to their homes. Trail users also have concerns about limited access during hunting season to the preserve that provides recreation for north island residents. The last public hearings about hunting in 2004 and 2005 did not change the regulations, despite the overwhelming support for the preserve being free of hunting.

The more than four hundred acres of Camano Ridge Forest Preserve are part of the Kristoferson Creek watershed. The forestland helps with aquifer recharge for island residents whose water supply depends on its sole source aquifer. The forest wetlands and stream also replenish Kristoferson Creek, a recognized salmon-bearing stream on the island.

Davis Slough Heronry

2003

TODAY

What a thrill to live where people will rally to save nests used a few months each year. Imagine gathering enough supporters to unite county and state governments with the help of a nonprofit. What a relief that the Whidbey Camano Land Trust had the expertise to make it work, knowing that great blue herons need space.

What makes the Davis Slough Heronry special is that people can't go there. It's set aside for herons and all the other critters that call it home. It took persuasion to keep humans out, but it worked, much to the relief of the many heron supporters who worked to save the land with the heron colony. The herons need space, and protecting that land gives other wildlife space, too. Herons aren't recluses, though, that stick to their trees. Although the heronry remains a habitat for the wildlife of the forest after the nesting season, the herons spend much of their time near their foraging sites.

Disturbing herons while they stalk the shore for prey will result in a scolding for a passing beach walker—and a scolding from herons is not to be taken lightly. As the herons slowly unfold their wings, take a step and lift off across the water, their piercing croaks let people know their errors absolutely. Sometimes, if careful, a beach walker can pass a heron on the beach without it flying off in a tiff. That is the perfect time to see its finery.

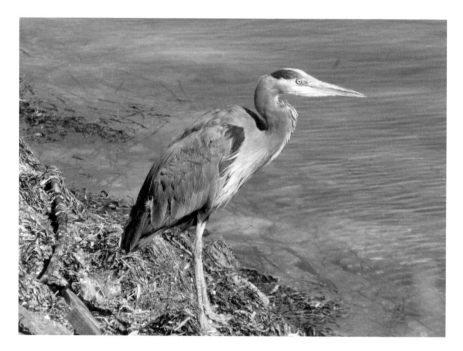

Great blue herons can be seen patiently waiting along the island's shorelines. *Robert N. Cash.*

What a stately creature a heron is, standing tall with plumes blowing in the wind. They travel the waters around the island, frequenting the shorelines and tidelands of English Boom Historical Park, Livingston Bay and Iverson Spit Preserve. With patience, bird-watchers can witness a heron snatch its prey, position it and swallow it and watch as the bulge slowly slips down the bird's long neck.

At low tide, it's common to see more than one hundred herons foraging in Skagit Bay. When the tide is in, they shift to the steep banks along the shoreline and roost in the trees. Being opportunists, the birds forage when the conditions are good. Even at night, they can be heard scolding whatever disturbs them as they fly to a less disruptive setting.

Rare is there a beach walk on the island without a heron present. When it does happen, search for other evidence of their presence. While artists spend time painting herons, the birds themselves create their own art—huge footprints, as big as a hand, etched across the empty sand.

Of all the heron experiences, a favorite is when they soar. Every once in a while when the winds are right, there's a heron riding the winds mixed in with the gulls and eagles soaring along the bluff. That must be the life!

Perhaps for some a great blue heron is nothing special. They're all over. But that's not a given; without nesting sites, herons cannot thrive. With the Davis Slough Heronry at the north end of Camano Island, visiting the island's beaches becomes more rewarding knowing that land has been saved just for these striking birds. Because enough people cared, herons do have a place of their own on Camano, but they come out to join the rest of the islanders much of the time.

Yesterday

The heron colony is near Davis Slough, which connects Skagit Bay to Port Susan Bay west of Leque Island. The slough is named after Reuben Davis, who resided on Camano Island before 1880 and was the oldest settler in the vicinity. Today, the slough and the bays are a regular foraging area for the great blue herons. Although the slough is nearly dry at low tide, it is regarded as the eastern boundary of Camano Island.

"The Davis Slough property is prime breeding and nesting habitat for herons, and there just isn't much of that remaining due to rapid population growth and development in the coastal areas of Puget Sound. Unfortunately, herons and humans find the same lands attractive for making their homes, and herons can't compete with people," said Ruth Milner, district biologist for the Washington Department of Fish and Wildlife, during the 2003 acquisition process.

The Washington Department of Fish and Wildlife began monitoring the Davis Slough heron colony in 1991. Milner said the herons might have moved from a Juniper Beach colony south of Highway 532 that was destroyed by logging and severe weather. "We track a lot of sensitive species," Milner said. "There is some indication that this critter may be declining, so we consider it to be a species of concern."

In the fall of 2002, the owner of the property with the heron colony contacted Milner about finding a conservancy buyer. The thirty-one-acre property surrounding the heron colony had been listed for sale with zoning for a six-home development. Although the Washington Department of Fish and Wildlife could not apply for a grant for purchase because the land didn't meet required criteria, Milner thought it might be worthy of local conservation efforts.

After Milner made a presentation to the Whidbey Camano Land Trust about preserving the land, the land trust indicated it would be willing to

pursue protecting the heron colony if local Camano support also became involved. After Friends of Camano Island Parks member Howard Shuman brought the proposal to the FOCIP board to help preserve the heronry, it agreed to do so.

The great blue herons are extremely sensitive to human intrusion, according to Milner. To raise chicks, they need secluded places close to wetland and estuary feeding grounds. Many heron colonies are abandoned because nearby human dwellings mean loss of peace and a sense of security. The herons abandon nests for safer spots to keep chicks free of discovery and harassment. Unfortunately, it's more difficult to create new colonies because of the development in Puget Sound coastal areas of both the forested habitat for nesting and the wetland/estuarine habitat for feeding.

The land trust and FOCIP spearheaded an effort to save the heronry. With the owner requesting $510,000, the organizations submitted a joint Island County Conservation Futures Fund application for half the funding; the other $255,000 would be obtained through private donations.

The owner needed to sell soon, so the property continued to be actively marketed. Despite competing offers and the selling of one of the four lots, the land trust secured an option to purchase the other thirty-one acres that included the heron nests, room for nesting expansion and a buffer to cushion the area for privacy. However, the owner still continued to market the land and had backup offers because the purchase option would expire on August 30, 2003.

To ensure that the heron colony and wildlife habitat was protected, Camano Islander and FOCIP member John Edison bought Parcel C, the ten-acre parcel with the nests, to gain time to acquire funds for the other two available parcels. The land trust continued to pursue the purchase of all three parcels (thirty-one acres) to protect all nests, as well as allow for expansion and space.

In July 2003, Island County approved $255,000 for the Davis Slough Heronry. Nearly 550 donors from Camano Island and beyond contributed to match the Conservation Futures funding.

The collaboration to raise the funds to protect the heronry and habitat included site management. The site is owned by Washington Department of Fish and Wildlife and managed as part of the Skagit Wildlife Area. Conservation easements, held by Island County and the Whidbey Camano Land Trust, prohibit all development and public access and require the site be managed for protection of the heron and wildlife habitat.

The land trust continued to work with adjacent landowners to the north and east to extend buffers. In 2009, it acquired a conservation easement

Tom Eisenberg, FOCIP co-chair, recorded nest trees at the Davis Slough Heronry after the nesting season. *John Custer.*

on thirty-six acres of critical great blue heron nesting habitat adjacent to the Davis Slough Heronry. The easement more than doubled the size of the area preserved for heron nesting at Davis Slough. The voluntary, legally binding easement donated by a generous landowner, who wished to remain anonymous, reduced the number of homes that could be built on the acreage from eight to only one.

The property has sweeping views of the Cascade Mountains and Skagit Flats, making the land potentially valuable for home sites. However, the owner realized that development would be detrimental to the heronry. Instead, the owner could continue to live on the land but still protect the nesting area forever. The donor's father purchased the property in the 1960s, and she watched the herons come and go each year. She stated during the land trust's announcement of the conservation easement:

> *My folks used to love to sit in the kitchen or living room and watch the herons fly up from the Skagit Flats, over the house, and into the heronry, sometimes dozens at a time. To see the herons sitting up there on their nests in the spring is an awesome sight. I'm so pleased that the property will never be developed. I knew that I could protect it during my lifetime, but now I know that it will remain undeveloped and preserved for future generations to enjoy.*

Because of the herons' sensitivity to human disturbances and their need for secure forests to successfully raise their young, successful heronries are located in specific forest habitats, away from homes but close to fertile feeding grounds. Without adequate protection, the birds seek better locations for their nests. Unfortunately, with herons and humans liking to build their homes in similar places, the birds become displaced.

"This new conservation easement provides additional forest for the colony to expand," said Milner. "The additional buffer area ensures that the birds feel protected and secure. We are thrilled that this donor is so supportive of the heronry's survival. As development continues to encroach upon wildlife habitat, we rely on private owners like her to help us with statewide conservation efforts."

The land trust is continuing to partner with the Department of Fish and Wildlife at the Davis Slough Heronry. They work together to remove blackberries and restore pastures back to forest habitat after the nesting seasons.

"This is a really rare and exciting opportunity to do something meaningful for great blue herons and safeguard them for the citizens of Washington State who love to see and hear them," said Patricia Powell, executive director of the Whidbey Camano Land Trust.

Legacy

For many, the great blue heron is a symbol of a pristine Puget Sound. People are drawn to these majestic and prehistoric-looking birds. Whether foraging, flying or roosting, they are part of the Pacific Northwest's natural heritage.

The heron is also an important biological indicator of the health of Puget Sound. Island County lists the great blue heron as a species of local importance and its habitat a local concern. The Washington Department of Fish and Wildlife lists the heron as a species of concern, and heron colonies are listed as priority habitats.

The Davis Slough Heronry is not open to the public because of the sensitivity of the herons. Courting and pairing begins in March, and fledglings are usually ready to leave nests in mid-July, according to Milner. March through July is the most sensitive time because of mating and nurturing young. Exploring the nesting site during those times would likely cause the herons to abandon the nests. They're very shy birds that don't take well to humans, and the safest bet is to leave the habitat alone, Milner said.

The Davis Slough Heronry is located between the rich feeding grounds of Skagit Bay and Port Susan Bay. With more than 50 percent of the Puget Sound's breeding population concentrated in a few colonies, heronry protection is extremely important to ensure the future survival of the great blue heron in northwest Washington islands.

The site is 75 percent forested with both native conifers (Douglas fir, western red cedar and western hemlock) and deciduous trees (red alder, big leaf maple, willow and cherry). Herons weave nests in high tree canopies. With long toes, they grip branches and twigs and construct nests side by side in colonies. The understory native vegetation of red huckleberry, Oregon grape, salal and sword fern provides habitat for ground- and shrub-nesting birds, as well as small mammals and amphibians. The historical pasture on the property, with a small orchard, occupies 25 percent of the land.

The herons can be seen at all times of the year on the shorelines, wetlands and meadows of Island, Snohomish and Skagit Counties. Protection of the heronry provides opportunities for bird-watching at the many preserves near the protected land: English Boom Historical Park, Iverson Spit Preserve and the Livingston Bay tidelands, Leque Island and the Nature Conservancy's Port Susan Bay Preserve. An interpretive display at English Boom Historical Park explains the life cycles and special characteristics of great blue herons.

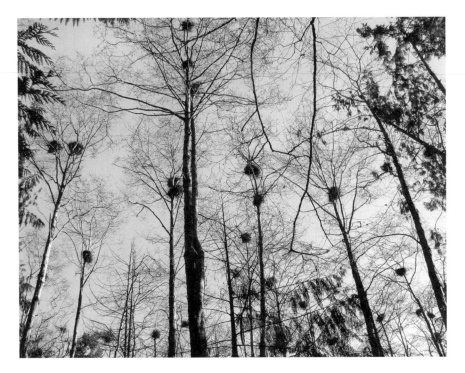

Great blue herons nest in a colony at the Davis Slough Heronry. *John Custer.*

The thirteen-thousand-acre Skagit Wildlife Area managed by the Department of Fish and Wildlife has six developed access sites to the water for viewing and public education and has extensive tidelands and intertidal marsh habitat for herons foraging. All of these protected sites provide public access and serve as viewing opportunities during nesting season as well as the rest of year.

Kristoferson Creek Habitat

2005 AND 2007

TODAY

Kristoferson Creek begins its journey at Kristoferson Lake and winds through beaver ponds, marshes, road culverts, forests and wetlands in an approximately two-mile journey to the Triangle Cove estuary on Port Susan Bay.

"Kristoferson Creek fascinates people," said Kris Kristoferson, whose great-grandfather Alfred Kristoferson purchased much of the watershed in 1912. "They wonder how such a small creek can support huge salmon. It shows that small creeks are just as important as the bigger rivers, and it's wonderful to see nature at work."

For a glimpse of this salmon creek in action, a platform and bridge allow for stream viewing and salmon watching at the Sapphire Drive parcel. A short walking path north of the kiosk provides another viewing area of the creek and wildlife.

Besides the seasonal chance of seeing adult salmon or redds (nests) in the shallow stream, interpretive signs at the kiosk explain the salmon's life cycle. Salmonids, including salmon and trout, belong to the family Salmonidae. They spawn in fresh water, spend most of their lives at sea and return to the rivers to reproduce.

Salmon spawn in the fall when adult female salmon dig redds in the stream bottom areas of moving water near riffles or the edges of pools. The

female moves gravel and small rocks with vigorous sweeps of her tail until a depression is formed. The eggs are deposited and then fertilized. When the eggs hatch in the spring, some salmonid fry move out of the creek to the salt water immediately, while other salmonid species move upstream.

Kristoferson Creek has another spot for public viewing on a sliver of property owned by Island County. A wood chip trail twenty-five yards from Can Ku Road leads to a viewing platform at the edge of a beaver marsh. The beavers have been active at this marsh for more than fifty-six years.

East of the platform trailhead, a short walk along Can Ku Road provides a view of a beaver deceiver where the creek goes through a culvert under East Camano Drive. The deceiver allows water to flow even with the beavers building dams. This area serves as an educational site to understand the relationships among beaver habitat, watersheds and salmon.

Juvenile coho about four inches long were identified in March 2005 above the beaver deceiver and downstream from the beaver marsh. Coho are known for rearing for a year or more in beaver marsh habitat before migrating downstream in spring high water. Where they actually spawned and hatched is unknown, but it wasn't Kristoferson Creek.

By walking Can Ku Road to the trailhead for Camano Ridge Forest Preserve, hikers can see the forested area of the Kristoferson Creek watershed. The forest wetlands drain into the creek's watershed.

The connector road between Lehman Road and Barnum Road provides a viewpoint of Kristoferson Creek's destination at Triangle Cove. Depending on the tide, this estuary may be mudflats or water, and the birding opportunities for shorebirds and waterfowl abound. Port Susan Bay is recognized by the Audubon Society as an Important Bird Area and as a Site of Regional Importance by the Western Hemisphere Shorebird Reserve Network (WHSRN). Places that are accepted into the network are recognized for their significance to the survival of hundreds of thousands of shorebirds that depend on them.

YESTERDAY

Kristoferson Creek starts meandering to Puget Sound from Kristoferson Lake on the Kristoferson Farm. Alfred Kristoferson, who owned a dairy in Seattle, bought the farm (K Ranch) on a warranty deed dated March 7, 1912, from James Moore for $55,000. He purchased the farmland with a

house and cabin that included 1,300 acres extending through timberland to the Iverson land and almost to the tidelands. Alfred bought the farm, which was principally stump land, both for future development and for his son August Sr., assuming his son Alfred would continue the family dairy in Seattle.

The farm, which stocked a large herd of Holstein cattle, became land for grazing and pasture. When the automobile replaced horse-drawn milk carts, Alfred moved the thirty city-bred dairy horses to the farm pasture, where they began learning the tasks of workhorses.

In 1961, August Sr. gained permission to dam the outlet of the lake, which doubled the lake's size to twenty-five acres. The lake collects the upland drainage, including two small, unnamed streams flowing under Cross Island Road. Utsalady Elementary School is located at the source of the Kristoferson Creek watershed. The creek drains from the lake southward through the wetland and through a culvert under the road until it eventually reaches Triangle Cove.

Since August Jr. died in 1977, his widow, Patricia, and their five children have jointly owned the property. Through the years, land within the original farm purchase has been sold and become the Camano Plaza shopping center, Camaloch Golf Course and residences. However, the extended family still owns significant parcels and remains stewards of the Kristoferson Creek watershed. "Of course Kristoferson Creek has sentimental value to our family, but it is also a precious resource and a natural wonder we should not take for granted," said Mona Campbell, one of August Jr. and Patricia's children.

After a salmon habitat study listed the creek as a potential salmon stream in 1999, the Camano Salmon Recovery Working Team, a subcommittee of Island County Water Resources Advisory Committee (WRAC), began exploring salmon possibilities in the creek. The Washington Department of Fish and Wildlife verified salmon redds in the lower stretches of the creek in November 2001, and adult salmonids were sighted in the lower stretches in December 2001.

At the base of the lower beaver dam, the Stillaguamish tribe verified salmonid fingerlings in July 2002. Beaver marshes have been documented as being important habitat for coho summer rearing once the fry leave the redds in the spring. Stream systems with extensive beaver ponds and wetlands accessible to coho have been recorded to have significantly more smolt (the stage of development when a young salmon is ready to migrate to the sea) than other systems in the Stillaguamish River basin.

Jason Griffith, a Stillaguamish tribe Natural Resources Department fisheries biologist, wrote the following in a letter supporting using Conservation Futures funds to protect the creek's beaver marsh:

> *Historically, the low elevation creeks of Puget Sound region had extensive beaver pond and associated wetland complexes that provided valuable rearing habitat for species such as Coho and cutthroat trout. Between the late 1800s and the present day, 81–96% of the beaver ponds in the anadromous zone disappeared from the Stillaguamish region, greatly reducing the capacities of the various watersheds to support species (Coho and cutthroat in particular) that depend on freshwater rearing habitat as juveniles (Pollock and Pess 1998). While most of these historic beaver pond complexes have been removed from the Kristoferson watershed, the one targeted in this project is still in properly functioning condition and is a valuable piece to protect.*

After the November 2001 and July 2002 sightings, the Island County Salmon Technical Advisory Group re-ranked the creek to the third-highest priority in the county. This made it the highest-ranked creek on Camano Island for salmon recovery.

In the fall of 2002, Friends of Camano Island Parks submitted a Conservation Futures Fund application to protect the Kristoferson Creek beaver marsh. The funding would have protected approximately forty acres of the watershed's well-established beaver pond habitat that included two beaver lodges, approximately four beaver dams, a valley bottom with a twenty-acre pond and twenty acres of wetland buffer of second-growth coniferous and deciduous trees, primarily alder, cedar and Douglas fir and shrub understory.

The application proposed preservation of the existing beaver marsh and wildlife habitat as open space to protect the area from development, retain it as wildlife habitat and watershed protection and preserve the rural quality of the island. With a strong desire by the Kristoferson family to preserve the historic farm and the open space components, including the beaver marsh, the owners gave permission for FOCIP to submit applications for Washington Salmon Recovery Funding Board and Conservation Futures funding as an effort to fund a conservation easement. Barbara Brock, a member of both FOCIP and WRAC, took the lead on the project.

Besides the natural habitat for plants and a wildlife corridor, the beaver marsh also provides a vital function to help moderate runoff. The marsh acts

Barbara Brock, a FOCIP volunteer, leads field trips at the Kristoferson Creek beaver deceiver to explain how water continues to flow while beavers build dams. *Author's collection.*

like a giant sponge, storing water during storm runoff and slowly releasing water during drier times.

Unfortunately, the animal shelter near the beaver marsh had a septic tank flood during the time of the application request. The issue of protecting a beaver marsh became controversial because of dams and flooding. Because of the controversy, the requests for Salmon Recovery Funding Board and Conservation Futures funds for the beaver marsh project were withdrawn.

As an alternative, FOCIP built a viewing platform on a small portion of county-owned land adjacent to the beaver marsh. This platform surrounded by bushes and under a forest canopy allows for a little peek of the marsh. Nearby and a short walk along the roadside across from the shelter is an opportunity to see the beaver deceiver that was installed near the edge of East Camano Drive and across Can Ku Road from the animal shelter. The deceiver allows the water to continue to flow to prevent flooding while the beavers continue to make their dams. This alleviated the controversy between beavers and flooding at the time and still does.

Despite this setback in preserving the beaver marsh, efforts continued to protect this little salmon-bearing stream on the island. The Whidbey Camano Land Trust filed another Conservation Futures Fund application in 2005 for Kristoferson Creek riparian and wetland protection. The land

trust's objective was to protect more habitat than the required setbacks along the creek and its wetlands. This would also provide access to the stream for public education and passive recreational uses. By selling the wetland and riparian areas of the commercial properties, the land most appropriate for development along East Camano Drive could be used and the landowners' investments would be enhanced.

With a combination of an acquisition and a conservation easement, an area of the second-largest drainage on Camano and Island County's most important salmonid stream was protected. However, besides supporting resident and anadromous fish (salmon as well as steelhead and cutthroat trout), the creek contributes a great amount of biodiversity for all wildlife species.

Steve Seymour, a Washington Department of Fish and Wildlife biologist, wrote the following in a letter supporting the acquisition:

> *On a statewide salmon recovery scale Kristoferson Creek may be considered unimportant, yet being one of the few salmon bearing streams in Island County, local efforts to improve the stream conditions are very significant. The idea of stream habitat improvement is new to the residents of Camano Island and as such work on Kristoferson provides the opportunity to focus positive community energy on not only habitat restoration challenges but on other more salient issues such as buffer widths, storm water controls, and general land stewardship. These later issues quickly move beyond the corridor of little Kristoferson Creek and begin to ignite discussions of the long term vision for the landscape of Island County as a whole.*

The thirty-year canopy of western red cedar, big leaf maple and red alder over dense shrubs of salmonberry, oceanspray, thimbleberry, Nootka rose and snowberry provides excellent thermal protection for the creek, shoreline stability and wildlife habitat. Small snags and downed woody material in the wetlands add beneficial nutrients to the water for a salmon nursery. Maintaining good water quality and riparian functions in Kristoferson Creek are also important to the health of Triangle Cove, a large pocket estuary that provides shelter and rearing functions for juvenile salmon with its marsh and mudflat.

"Our natural resources mapping work in 2004 identified Kristoferson Creek as one of the highest protection priorities on Camano Island," said Whidbey Camano Land Trust director Patricia Powell. "Not only that, the land boasts fish and wildlife habitat, wetlands, creek access, rare native species and community open space."

In between the two Conservation Futures Fund application submissions, the salmon continued returning to the creek. During the winter of 2004, the Washington Department of Fish and Wildlife documented one hundred chums for Kristoferson Creek. In the spring of 2005, both juvenile chinook and coho were verified in the creek.

On January 23, 2006, the Island County Board of Commissioners approved the purchase of two and a half acres of property, which would give access to 250 feet along both sides of Kristoferson Creek. While the acquisition paid the owner for developable land within commercial and light industrial zoning, this added an additional buffer to the existing regulatory setbacks that would impact the wildlife habitat.

"This purchase wouldn't have been possible without strong partnerships. It took the participation of a willing landowner who sold his property at a lower-than-appraised market value, the actions of concerned Camano citizens who contacted the County Commissioners in support of the project, and County Commissioners who saw the value of using Conservation Futures funds to purchase the site," Powell said.

In 2007, Drew Bowlds, owner of AAA Camano Heated Storage Facility, donated 7.4 acres of his property at Kristoferson Creek to the Whidbey Camano Land Trust. This land is adjacent to the 2.5 acres previously protected for Island County by the land trust. In total, the project protects approximately 910 feet of Kristoferson Creek shoreline, 6.5 acres for wetland and the surrounding riparian habitat. The forested wetland both provides additional wildlife habitat and protects water quality.

"It made sense from a business perspective and it was an opportunity to help the creek stay healthy and possibly even improve over time," Bowlds said. "This project is a great example of partnership between development and environmentalism. I can use the property farther away from the creek for my facility and the Land Trust can manage the creek and wetlands for the important natural habitat qualities."

The result of the two acquisitions is nearly ten acres of high-priority salmon and wetland habitat along the lower portion of Kristoferson Creek permanently protected through collaboration with Island County, Whidbey Camano Land Trust and cooperative landowners. After obtaining bridge and viewing platform permits, Friends of Camano Island Parks constructed a small platform and bridge that allow visitors a chance to see a salmon stream. Islanders now have a permanent, safe and convenient public access to the creek for education and public viewing.

LEGACY

Protecting the Kristoferson Creek watershed remains a priority area for the Whidbey Camano Land Trust. Protecting riparian habitat along the creek corridor benefits the fish and wildlife. Providing recreational and educational opportunities not available elsewhere on the island benefits the citizens. Riparian stream corridors and wetlands are recognized as some of the most important features of the island landscape because of their value for storm-water retention, water quality, fish and wildlife habitat and aquifer protection.

After the creek flows under Russell Road through a private pond, it discharges into Triangle Cove, a two-hundred-acre estuary that has never been totally diked or gated. The cove is a rich area of fresh water and salt water mixing to provide food and habitat to both fish and birds. Triangle Cove connects to Port Susan Bay and is directly across from Hat Slough, the current mouth of the Stillaguamish River. The location of Triangle Cove makes it an important resource for salmon leaving and returning to the Stillaguamish River.

Kristoferson Creek serves as a refuge habitat providing critical fresh water for the transition of young fry migrants. The creek also carries nutrients and organic matter to the coastal shoreline. With the creek and Triangle Cove being within one tidal cycle of the mouth of the Stillaguamish River, the tide and current assist the fry in their journey to sheltered waters necessary for their survival.

Estuaries and small channels are the locations where fry, emerging from the freshwater river, become adjusted to salt water and adults, returning from the ocean to spawn, readjust to freshwater conditions. Anadromous fish from the Stillaguamish River would be expected to use near-shore and estuarine habitats of Port Susan. Estuaries, their channels, vegetated marshes and mudflats are all critical habitats for anadromous fish because these habitats provide a variety of critical functions for both their juvenile and adult life stages. Kristoferson Creek's location places it in the top priority geographically for salmon protection and restorative actions.

After an extensive study and sampling between 2008 and 2013 of the streams in the Whidbey Basin, which included the Skagit, Stillaguamish and Snohomish Rivers, the Skagit River System Cooperative released its report *Juvenile Chinook Salmon Rearing in Small Non-Natal Streams Draining into the Whidbey Basin*. During creek samplings in 2010, the cooperative's researchers discovered the juvenile salmonid species present in Kristoferson Creek

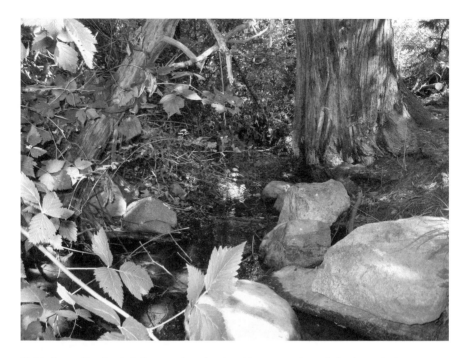

Kristoferson Creek winds its way along banks with trees, rocks and shrubs on its journey to Triangle Cove and Port Susan Bay. *Author's collection.*

included chinook, steelhead, coho, cutthroat and chum. Juvenile salmonid use has also been identified at the even smaller stream near Cavalero County Park. The report indicated:

> *Streams of the size in this study are often not considered salmon habitat because many flow seasonally and do not provide habitat for spawning salmon. However, we found that numerous small streams entering the Whidbey Basin do provide rearing habitat for fry migrant Chinook salmon originating from the three nearby rivers (Skagit, Snohomish, and Stillaguamish).*
>
> *Since no adult Chinook salmon spawn in the small streams we sampled, juvenile Chinook salmon found using these small streams are of non-natal origin, meaning the juvenile salmon came from a different stream (i.e., one of the three Whidbey Basin rivers) through its estuary and into the marine waters of the Whidbey Basin, and then into the Whidbey Basin small stream.*

To enhance the Kristoferson Creek watershed, the Snohomish Conservation District and Island County Public Works Department have initiated a watershed stewardship program, which includes a creek inventory and development of a restoration plan. Citizen stewardship activities by Whidbey Camano Land Trust and Friends of Camano Island Parks volunteers and community members continue to provide restoration enhancements because of the creek's significance as an important wildlife habitat.

Livingston Bay Tidelands

2006

Today

Not everyone understands what the big deal is about Livingston Bay. A drive to the Fox Trot Way road-end parking and a climb over the driftwood for a view of a pretty bay at high tide is nice. However, if the tide is out and the view is a field of mud and more mud, the prettiness factor diminishes quickly. What's available at this road-end wayside is a jumble of mega-sized

Livingston Bay is included in the Port Susan Important Bird Area and the Western Hemisphere Shorebird Reserve Network. *Author's collection.*

driftwood logs to clamber over to a field of stinky, slimy mud—gooey stuff that quickly takes on a quicksand effect if walked on.

If, however, looking at the endless mud makes you squirm with delight as you peer over what is really more of an oasis than a desolate wasteland, you'll see wildlife crawling, scampering and soaring. With binoculars or a scope, you can see dunlins and sandpipers scurrying across the sand. Killdeer screeches will warn you to scram. Peregrine falcons roosting on a tree on the shore may zip to the bay, and before you can blink, the shorebirds will suddenly take wing in their choreographed flights.

There's much to appreciate at this tiny road end. Plenty of logs allow visitors a chance to ponder just what a treasure Livingston Bay really is.

YESTERDAY

Early in the twentieth century, West Pass was dredged at the head of Port Susan Bay to link the Stillaguamish River to Skagit Bay. Before this dredging and afterward, Livingston Bay, the northwestern section of Port Susan and west of the Stillaguamish River's mouth, has always had a strong freshwater influence that included large sediment deposits from the river. Because of these deposits, Livingston Bay has become a bay with significant tidal variation.

Besides the logging on the mainland that caused the increased sediment deposits into the bay, lumbermen logged the land behind Triangle Cove and Livingston Bay on the island. When the large mill closed at Utsalady, small operations took over and included logging camps at the northeast and northwest areas of Livingston Bay.

A few millworkers bought property near Livingston Bay in the 1890s after the Utsalady mill closed. Their work to log and clear the land for farming included the labor-intensive struggle of removing slash and stumps. Eventually, they brought cows to graze stumped fields and could build houses and barns.

Aubrey "A.G." Nelson came to Camano with his parents "to escape the 1918 rat race." They bought from Alfred Leque ninety-six acres of what had been a logging camp. "The acreage was dotted with bunkhouses and stumps," Elizabeth Nelson writes in *Camano Island: Food, Facts, Fun.* "A skid road ran from what is now Camano Lutheran cemetery, through the farm and out to a wharf in Livingston Bay. Logs were taken from there at high tide

to the lumber company in Stanwood. Other spur roads ran down through the woods on the present Sunrise Boulevard to join the main skid."

Aubrey and his father dug up the greased skids used for logs. They regraded and ditched the roads. Using a portable mill to cut lumber, they then constructed buildings. They also dug a forty-foot-deep well by hand.

Much of the island farmland was poor because of burned and eroded soils, except in lowlands. The Livingston Bay area had the most farming on Camano Island and was named after the first farmer, Jacob Livingston, and his brother David, who filed a homestead in 1862.

Besides converting the logged land to farms, the salt marshes were converted for farm use as well. About 85 percent of the Stillaguamish River's salt marsh estuary was converted to agriculture between 1870 and 1968, according to the Salmon Habitat Limiting Factors report for the Stillaguamish watershed.

"The marsh land was drained and became very profitable. Oats were the main crop. What fun it was to go and sit on the stacks of oat sacks and watch the threshing and the old steam donkey keep things moving!" said Ada (Frostad) Olson, whose father bought land from Livingston.

Hunting supplemented the farmers' income. They would sell to commercial market hunters paying fifteen cents for teal and bufflehead and twenty-five cents for mallard, wigeon and snow geese. This changed with the 1918 Migratory Bird Act when a hunting season came into effect.

Other people pursued shellfish farming. George Kosmos started the Camano Blue Point Oyster Company after purchasing 5,300 acres of tidelands between Juniper Beach and Livingston Bay. Of that, 3,500 acres were suitable for growing oysters. After planting twenty cases of oysters from Japan, the company anticipated being able to fill the growing demand for commercial oysters.

In September 1932, the first scow load of oysters was towed from Livingston Bay to the Stanwood wharf. During the 1930s, oysters began to flood the markets. As the industry's popularity increased, the quantity of oysters seeking a market increased. Both this sudden expansion and the Great Depression of the early 1930s caused marketing problems. There was an enormous overproduction of oysters, and many oyster growers and packers were forced to liquidate.

In 1938, the *Twin City News* reported, "Mr. Kosmos says he can buy oysters at 30 cents per gallon and the cost of harvesting them is 24 cents, so not worth harvesting." Kosmos was still hoping for smaller oyster producers to drop out so that prices and profits would increase. On April 27, 1939, the newspaper announced the reopening of the plant.

Cooperative Food Products took over the Blue Point building in January 1940. The company specialized in canning rabbits and fish. After that, Edlund Shipyards leased the Stanwood building, and it was used as part of the shipyard to build seven barges for the United States Army.

The Gaetz Oyster Company purchased the Blue Point flats (Livingston Bay) in 1943. Oysters from all over Puget Sound and Port Susan Bay were processed in the Stanwood Hardware Building (Home Center). Unfortunately, plans changed when the Russian tanker *Donbass* broke apart in the Aleutians in February 1946, and the tanker's bow was towed to Port Susan. Although it's unclear why the bow of this decrepit tanker full of oil was towed to Port Susan, oil leaked, and the spill contaminated the Livingston Bay oysters. Gaetz Oyster Company closed the oyster beds and stated it would use Samish Bay for its oyster supply.

Commercial shellfish harvesting in Livingston Bay became a controversy in 1974 when the *Stanwood News* reported that two clam-digging barges, *Diane* and *She Wolf*, were working in the bay. After public complaints, the *Diane*'s permit was revoked. Public hearings occurred, and the English Bay Enterprises' shoreline application was approved and the company received a permit from the Department of Fisheries. However, the Island County Board of Commissioners denied English Bay Enterprises' application for a substantial development permit to harvest clams from all its leased private tidelands in Livingston and Port Susan Bays. The Shorelines Hearings Board supported the county's decision, and the hearings board decision was appealed to the Superior Court for Thurston County and upheld on August 2, 1975. In September 1977, the Washington Supreme Court affirmed the decisions of the Shorelines Hearings Board and the Superior Court.

Livingston Bay's proximity to the mouth of the Stillaguamish River creates a significant freshwater influence to the estuarine features of the bay. However, only three square kilometers of the Stillaguamish salt marsh estuary in Port Susan were left by 1968, according to the Salmon Habitat Limiting Factors report. Even though the size of the delta of the river was and still is increasing due to sedimentation from land uses upstream, the mud and sand flats have less value to salmon than the original salt marsh.

The Stillaguamish River is the fifth-largest tributary entering Puget Sound. Between 1956 and 1965, it was estimated to have contributed approximately 21 percent of the anadromous fish (salmon, steelhead and cutthroat trout) in the sound. The adult salmon spawn each fall upstream in the river. Each spring, the juvenile salmon swim downstream and enter Port Susan Bay in

search of estuaries for food and shelter. They later move into salt water to mature for two to six years and return to fresh water to spawn and die.

To aid in salmon restoration, the Nature Conservancy acquired more than 4,100 acres of salt marsh and tidal flats in the northern portion of Port Susan Bay near the mouth of the Stillaguamish River in the summer of 2001. The area, south of Stanwood, is now known as the Port Susan Bay Preserve. The conservancy purchased an additional 43 acres in 2009. Within this new acreage on the western shore of Livingston Bay, the organization restored a 10-acre pocket estuary in 2012. This estuary can be seen in the distance from the dike at Iverson Spit Preserve.

During the restoration, the conservancy removed a section of man-made dike that blocked natural inlets and outlets for the estuary and made it a saltwater lagoon. By restoring regular tidal connection between the pocket estuary and the bay, the project created a rearing habitat for chinook salmon, coho, steelhead and bull trout while reducing breeding mosquitoes through regular tidal flushing. The pocket estuary provides juvenile fish migrating out of the nearby Stillaguamish River refuge and food in Livingston Bay.

Together, the Port Susan Bay restoration and the Livingston Bay pocket estuary restoration return some of the essential natural processes back to the northern end of Port Susan. Both of these projects were highlighted in the Conservation Action Plan for the Port Susan Marine Stewardship Area. This collaborative planning effort is coordinating conservation actions among more than thirty partners around the bay to work toward a healthy and sustainable Port Susan.

Adding to these restoration efforts, the Whidbey Camano Land Trust purchased 3,160 acres of Livingston Bay tidelands in 2006 with a grant from the Washington Salmon Recovery Funding Board and a generous donation from Floyd Jones. His wife, Delores, was the granddaughter of P.J. and Anna Sundin, Swedish immigrants who purchased property on Livingston Bay in 1905.

"There's tremendous loyalty to Sundin Beach by a lot of people," Floyd Jones said. "They come by and say, 'I swam here as a kid.' It's a special place. So when it came up again [for sale], I thought as a member of the family I ought to help buy this. To me it was kind of a sentimental thing. So I did it; no questions asked. And I'm glad I did. We won't have to worry about it in the future."

Some of these tidelands are adjacent to Iverson Spit Preserve. The Whidbey Camano Land Trust continues to work on protecting this area of Camano Island, as it fits its criteria of a priority for nature, willing landowners and available funding through grants.

Dunlin fly in between foraging stops at Skagit and Port Susan Bays. *Robert N. Cash.*

While grant money aids protecting the tidal lands to assist salmon restoration, its importance for shorebirds has been noted as well. The Greater Skagit and Stillaguamish Delta, of which English Boom Historical Park and Livingston Bay are a part, was recognized as a site of regional importance in the Western Hemisphere Shorebird Reserve Network in 2013.

Research and surveys by Ruth Milner, biologist with the Washington Department of Fish and Wildlife, and Gary Slater, executive director of Ecostudies Institute, led to the designation that recognizes the Greater Skagit and Stillaguamish Delta—which the birds use as one connected habitat—as an important stopover and wintering ground for more than twenty thousand shorebirds a year. Milner has spent the last decade learning how the birds rely on these local bays for their survival. Her diligence and Slater's in surveying the areas prove the connection between the Skagit and Stillaguamish deltas and the important habitat they provide.

Legacy

Livingston Bay serves as a vital link on the Washington coast for estuarine and near-shore conservation. Its wealth of biodiversity plays a key role in the lives of dozens of internationally important estuarine-dependent species.

Located within the island watershed and near the mouth of the Stillaguamish River, Livingston Bay provides both critical feeding grounds for water birds and habitat for salmon and other fish species. Because it is recognized as having these significant fish and wildlife resources, it is the focus of several ongoing conservation efforts.

The Whidbey Camano Land Trust owns Livingston Bay tidelands with the goal of expanding protection to more of Port Susan and the Greater Skagit and Stillaguamish Delta. In addition, a coordinated effort has established a Port Susan Marine Stewardship Area that includes the entire Port Susan Bay and surrounding drainage basins, including Livingston Bay and Iverson Spit Preserve. The non-regulatory effort is a partnership between Snohomish and Island County Marine Resources Committees, Tulalip tribes, the Stillaguamish tribe, the Nature Conservancy, Washington State University Extension of Snohomish and Island Counties and Washington Sea Grant, with support from the Northwest Straits Commission.

The Port Susan Bay and Livingston Bay restorations will bring essential natural processes back to the northern end of Port Susan. Both of these projects are highlighted in the Conservation Action Plan for the marine stewardship area to work toward a healthy and sustainable Port Susan.

Livingston Bay, as an estuary, is part of the food web with its intricate connections. It's a nursery for shellfish and forage fish, a migratory stop for thousands of shorebirds and waterfowl and a habitat for the local species. With more than 165 species of birds identified in its surrounding area, Livingston Bay is an ideal spot to see the connections in nature.

As a five-star resort for shorebirds, waterfowl, raptors, juvenile and adult salmon, raccoons and even deer, Livingston Bay is much more than a deserted mudflat that isn't always pretty. Instead, consider it a diamond in the rough—plenty valuable, but it might not always shine. Because of this hidden dazzle, Livingston Bay needs all the more supporters understanding and fighting to keep it a thriving food source near the mouth of the Stillaguamish River.

Barnum Point Preserve

2012

TODAY

When the new preserve at Barnum Point opens, enjoy spectacular views of the Cascade Mountains across Port Susan Bay. On a clear day, Mount Rainier may stand tall above the clouds toward the southeast. Watch for harbor seals in search of the elusive salmon heading to the mouth of the Stillaguamish River. Witness river otters scampering from beach to water gobbling on mussels or riding the waves.

During low tide, search for agates or find some driftwood and dangle your feet as you rest. See eagles feeding on the bay at low tide, training their young in the summer. Wait long enough and you might see them dip their wings in Port Susan as the tide creeps into the shore. High tide offers its own pleasure. Walk the trails to investigate the fields and woodlands. From the bluff, enjoy whistling winds and pounding waves. Bring binoculars and see the migrating shorebirds and ducks flock the bay.

To assist Island County in opening the new preserve, Friends of Camano Island Parks is working with park staff to construct a scenic loop trail with a bluff view of Port Susan and a moderately steep hiking trail to the beach. The significant elevation change from bluff to beach might discourage some hikers. The tidal fluctuation on the beach means knowledge of the high and low tide times is important for beach access.

Amenities will include viewing platforms with benches, trails and information kiosks. To respect the private property of the residents surrounding the preserve, stay on the trails and within the wooden fences that mark the borders. Access to the preserve will be from a parking area at the end of Sunrise Boulevard.

Yesterday

S.J. Barnum arrived on Camano Island in 1904. After searching the island by boat, he bought 110 acres and cleared 40 of them for a farm. Noting that his place jutted into Port Susan Bay, he called it Barnum Point.

The Barnum family had chickens, cows, pigs, vegetable gardens and a large orchard. Before there was a road, the scow that brought supplies to the mill across Triangle Cove also picked up Barnum's cash crops of potatoes and oats. The Barnum strawberries were some of the first to ripen during the season because of the long afternoon sun exposure at the point.

"We had a great, huge garden and a big orchard. We depended on what we raised. There were no roads, no schools, no churches. Just a collection of small logging camps," said Barnum's daughter, Catherine Hedges, during a 1992 interview with the *Stanwood/Camano News*.

On the property, Barnum built a school for grades first through third for his daughter and the neighborhood kids, according to Hedges. Later, a larger school was built in the area for grades first through eighth.

A swing bridge to Stanwood was built in 1909, and the road (now State Route 532) ended at McEachern's Corner (now Terry's Corner). Mail service was delivered as far as the road end, and people rode horses to pick up their mail. After Barnum became a county commissioner in 1912, he arranged the construction of Sunrise Boulevard. This connected Barnum Point to McEachern's Corner.

In 1992, a portion of the property became the Inn at Barnum Point. Barnum's granddaughter, Carolin Barnum Dilorenzo, as a little girl played on the fields and beaches of Barnum Point and swam and boated in Port Susan Bay. She returned to be nearer to family and opened the bed-and-breakfast to share a bit of paradise. Visitors can still enjoy island living in one of the three guest rooms that all have a water view and access to the beach.

Working together, Island County and the Nature Conservancy purchased fifty-two acres of Barnum Point property. Island County acquired twenty-

Kristoferson Creek flows into the Triangle Cove estuary that Barnum Point shields. This provides the freshwater and saltwater mix beneficial for juvenile salmon. *Robert N. Cash.*

six acres and a conservation easement on another twenty-six acres from the conservancy, which purchased the land in August 2012 from the family who had owned and cared for the property for generations. The Nature Conservancy protects natural areas by purchasing them. The nonprofit organization worked with the county to obtain grants to buy the property, according to Kat Morgan, Port Susan Bay manager for the Nature Conservancy.

"This is a great opportunity to preserve this vital shoreline and the intertidal processes that sustain Port Susan Bay and Puget Sound. We're grateful for the state grant programs and the work of the Nature Conservancy to assist us in preserving public access to this wonderful place for future generations," said Helen Price Johnson, chair of the Island County commissioners, during the announcement of the purchase.

Funding for the project came from state and federal grants and private donations. The Nature Conservancy received a $1 million grant through the state's Recreation and Conservation Office's (RCO) Estuary and Salmon Restoration Program. Island County received a $1 million grant from RCO through its Aquatic Lands Enhancement Account (ALEA). ALEA, funded by revenue the state generates from tideland leases, restores the natural ecological functions of the shoreline and provides public access to the water. The conservancy also gave Island County a grant of $50,000 from private donations for management of the property.

"This has been a great team effort to ensure that Camano Island residents will be able to enjoy this beautiful shoreline far into the future, while it continues to play an important natural role in Puget Sound," said Mike Stevens, Washington State director for the conservancy.

The purchase ensures public access to a natural shoreline and a healthier Port Susan Bay. The property contains woodlands and dramatic views, from both the beach and a 150-foot bluff, of the Cascade Mountains and Mount Rainier across the bay to the southeast. The county will maintain the park as a natural recreation area with trails and beach access, while conserving natural habitat, said Price Johnson.

LEGACY

Besides providing public access to Port Susan Bay, preserving these fifty-two acres of Barnum Point from residential development helps to ensure good habitat for juvenile salmon and other marine life. The Nature Conservancy

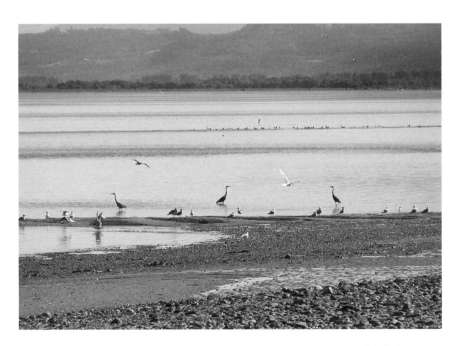

Herons and gulls forage on mudflats of the Greater Skagit and Stillaguamish Delta. *Author's collection.*

and Whidbey Camano Land Trust have protected more than seven thousand acres of tidelands in Port Susan Bay since 2001. As one of the largest relatively undeveloped bays, the area plays a significant role in the overall health of Puget Sound.

Located between two of Puget Sound's largest rivers, the Skagit and the Stillaguamish, Port Susan Bay supports juvenile salmon, shorebirds and waterfowl and family farms. Even gray whales find their way into the bay to feed on tiny invertebrates in the mud.

This new preserve also ensures habitat for the wildlife needing space on the island. The fifty-two acres remain natural for wildlife to forage, rest, breed and travel morning or night. It's a place for residents and visitors to walk the fields, woodlands and shoreline as guests learning about the natural features of Camano Island's land and water.

Additional Camano Island Parks

S hortage of public places to enjoy island living was the complaint in the 1940s and initiated the origin of Camano Island State Park. Between the 1949 opening of the state park and the 1994 purchase of Cama Beach State Park, not much public land was added. In fact, the July 6, 1967 edition of the *Stanwood News* reprinted a *Whidbey News-Times* article, "Park Shortage Confronts Tourist-Loaded Camano." These are the parks that were available prior to 1994.

The logging and shipping days of Utsalady Bay have become recreational. *Author's collection.*

UTSALADY BEACH AND BOAT LAUNCH

In the late 1800s, Utsalady was booming as a port with a sawmill. Today, it's a beach community. The boat ramp is near private beach homes. The area is sheltered from the prevailing winds and is one of the safer spots to moor a boat on Camano Island.
• Single-lane concrete boat ramp
• Grassy area with picnic tables
• Stairs to beach
• Half acre with 380 feet of public tidelands

UTSALADY POINT VISTA PARK

• One-acre pocket park with picnic tables
• Scenic bluff viewpoint of Utsalady and Skagit Bays, Cascade and Olympic mountain ranges and Whidbey Island
• Historical marker recognizing sawmill era
• No beach access

MAPLE GROVE PARK AND BOAT LAUNCH

• Single-lane concrete boat ramp
• Picnic tables
• One acre with 250 feet of public tidelands west of road end
• View of Polnell Point on Whidbey Island 3.5 miles across Saratoga Passage
• Adjacent to beach homes

CAVALERO COUNTY PARK AND BOAT RAMP

• Single-lane boat ramp useable at high tide and not appropriate for large boats because of the steep access road

• Only public ramp on Camano Island with access to Port Susan Bay
• Picnic tables with barbecue grills
• 250 feet of public tidelands
• Scenic viewpoint of Cascade Mountains
• Swimming at lower tides in shallow sandy tidelands
• Half acre

Tillicum Beach

• Picnic tables
• Half acre with eighty feet of community beach dedicated to public
• Scenic viewpoint of Cascade Mountains
• Kayak and canoe access with driftwood along shoreline that may cause difficulty at high tide
• In the middle of a community of beach homes

Walter G. Hutchinson County Park

• The Walter Hutchinson family donated this five-acre park to Island County in 1979.
• Nature trails (half mile)
• Picnic tables
• Quiet, forested park

Future Camano Island Park or Preserve— Henry Hollow

Island County used Conservation Futures funding to purchase approximately 7.2 acres adjacent to Henry Lane (commonly referred to as Henry Hollow). The county worked with the family and their real estate agent to preserve the land in late 2008 and 2009. When the property opens to the public

Carol Triplett, FOCIP co-chair, investigates the future Henry Hollow preserve that will provide walking access to a west Camano Island beach. *Tom Eisenberg.*

after a bridge is installed, it will provide walking access to the shoreline on Saratoga Passage on the island's west side.

Camano Island

A COMMUNITY WILDLIFE HABITAT

As I sit on the beach listening to gulls squawk, kingfisher chatter and great blue heron scold, I smile. This is my paradise—Camano Island—and I don't have to fear for its future. I'm too thankful for all the islanders involved in the Camano Wildlife Habitat Project who share the vision of creating an island in harmony with nature—one yard at a time.

Currently, there are more than eight hundred properties on Camano Island, including private residences, businesses and community areas that the National Wildlife Federation recognizes as Certified Wildlife Habitats. Looking at a map of these habitats, they are located throughout the island and do exactly what the community project seeks to do—create, preserve and restore wildlife corridors to provide the wildlife their essential needs of food, water, shelter and space.

At my Certified Wildlife Habitat where I sit, I see and hear the evidence of success as two juvenile eagles cry out for mom or dad, a Caspian tern follows its parent with a pleasant little squeak, a seal pup barks for its mom and seven killdeer warn me to get out of the way. My strolls along the beach are less anxious now that we have the Camano Wildlife Habitat Project striving to include community involvement at all levels to share our island with wildlife. This also conserves our water resource and enhances the island's natural beauty.

In 2002, Friends of Camano Island Parks sponsored the wildlife project, and it's a successful project because of all the people and organizations willing to participate. After discovering that Tukwila, Washington, was the

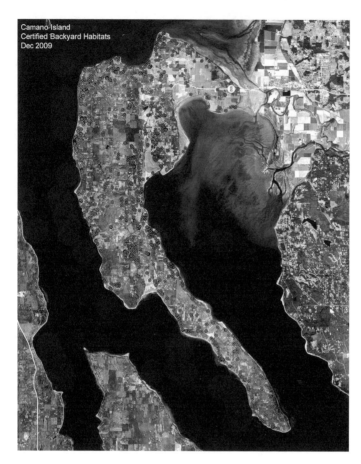

Camano Island
Certified Backyard Habitats
Dec 2009

With more than eight hundred Certified Wildlife Habitats on Camano, public spaces and private properties link to restore wildlife corridors. *Roxie Rochat, Camano Wildlife Habitat Project.*

fourth community in the nation certified by the National Wildlife Federation as a Community Wildlife Habitat, it seemed like an easy achievement for Camano. Although we have an exemplary community project with incredible participation, it certainly took perseverance. It took the diligence of a lot of people who care and share a community vision, and it worked. Camano Island became the tenth certified Community Wildlife Habitat in the nation in 2005.

To begin the Camano project, I went to meetings, mentioned the habitat project and hoped someone would take the initiative. Someone did when she said to me, "There are groups for some people and not for others." Recognizing this group was not going to help, it was the kick I needed to move from talking to doing. I decided to charge forth by taking the National Wildlife Federation's Habitat Stewards Host Training and hoped I would attract others to join the endeavor.

Besides completing an application, I needed references. This brought me to FOCIP, and being the can-do and visionary group it is, co-chairs Carol Triplett and Pam Pritzl not only agreed to be references but also suggested asking the FOCIP board to sponsor the project. The board agreed, and I walked out of the next board meeting with a habitat steering committee of five, a $500 budget and the first steering committee meeting scheduled in two weeks. That was in July 2002. With a steering committee of eleven, we publicly launched the habitat project in February 2003 and have been adding yards, people, organizations and now other communities to the cause ever since.

With help from a Stanwood-Camano Area Foundation grant, we were able to offer Habitat Stewards Training, and twenty-seven stewards took the course and agreed to volunteer fifty hours to enhance the project. Part of the steward work has been at individual yards to help people landscape for wildlife. In community areas, Bev Reaume and LaLee Burrill, steering committee members, and several stewards and FOCIP volunteers have established Certified Wildlife Habitat demonstration gardens at Four Springs Lake Preserve, the Camano Center and Vista/Madrona Fire Station. Reaume and Burrill also worked with the Elger Bay Elementary School staff to create a schoolyard habitat and Elger Bay Preserve nature trail to offer the students an outdoor classroom.

With banners and tables at grocery stores, nurseries and events, Habitat Stewards promoted our community vision of an island in harmony with nature. Being out in the community proved to be a major success to our goal of becoming a Community Wildlife Habitat, and we are thankful to the businesses and organizations that would allow us to share our vision at their venues. Monthly interpretive programs and an annual garden tour continue to spread the message of landscaping for wildlife and responsible gardening.

Besides the budget from FOCIP, grants helped with the community certification requirements of providing demonstration gardens and schoolyard habitats. It's great having a vision and wanting people to participate, but it also helps by providing a way to make it happen. A grant from the Camano Island Watershed Program made it possible to extend our committee vision into a community one.

Working with the National Wildlife Federation's Certified Wildlife Habitat program not only gave us the credibility of a national organization that has certified more than 175,000 wildlife habitats during the past forty years, but it also connected us to a national trend. When you don't have money to buy land to preserve the natural world, there are still ways to make a difference

Bev Reaume, a Camano Wildlife Habitat Project habitat steward, coordinates work parties at the wildlife habitat demonstration gardens. *Author's collection.*

and allow people to care and take action. Through the National Wildlife Federation, not only were we able to get promotional and educational materials, but we also received grant money to assist with the schoolyard habitats and training for teachers.

Anthropologist Margaret Mead is noted for stating, "Never doubt that a small group of thoughtful, committed citizens can change the world. Indeed it's the only thing that ever has." My eyes mist every time I hear, read or say those words because people working together in a community do make a difference. That difference in one community spreads to others, as can be vouched by more than fifteen community wildlife habitats now certified in Washington State and more than seventy communities in the nation.

Camano Islanders have shared a vision in creating an island in harmony with nature. It's helping our island paradise thrive. As the Certified Wildlife Habitats connect with the parks and preserves, the wildlife corridors return. A wildlife sanctuary in our own yards makes it easy to share our space with the natural world and love our island paradise.

Supporting Organizations

FRIENDS OF CAMANO ISLAND PARKS

FOCIP promotes the preservation and protection of the wildlife, as well as the scenic and recreational resources located on Camano Island. The group achieves this by providing stewardship activities and projects that include implementing Camano Island park improvements and maintenance; offering educational programs and activities compatible with the preservation of the natural habitats and wildlife on Camano; and advocating for acquisition of appropriate Camano Island properties for the purpose of new state or county lands for parks or preserves. FOCIP is a 501(c)(3) nonprofit community organization, incorporated in 1993.
• Visit Friends of Camano Island Parks on the web at www.friendsofcamanoislandparks.org.

CAMANO ACTION FOR A RURAL ENVIRONMENT

CARE is a group of Camano Island residents who care about the future of the island and are working to preserve the rural character. CARE projects include protecting the island's sole source aquifer, promoting responsible

land use, encouraging good stewardship and preserving the integrity of the island's natural habitat. CARE is a 501(c)(3) nonprofit citizen organization based on Camano Island.
• Visit Camano Action for a Rural Environment on the web at www.camanocare.org.

WHIDBEY CAMANO LAND TRUST

The land trust protects the natural habitats and rural lands on Whidbey and Camano Islands in partnership with landowners and the broader community. The land trust is a local, nonprofit, non-political organization that assists private landowners to voluntarily protect their scenic, wildlife habitat, natural, historic, farm, forest or shoreline properties. The land trust also works with community groups to protect those places that citizens value and that are important for current and future generations. Activities include acquiring land and conservation easements, offering expertise and education to private landowners, providing stewardship on landholdings and collaborating on land conservation projects. WCLT is a 501(c)(3) nonprofit community organization based on Whidbey Island, incorporated in 1984.
• Visit Whidbey Camano Land Trust on the web at www.wclt.org.

THE NATURE CONSERVANCY

The Nature Conservancy is a leading conservation organization working around the world to protect ecologically important lands and waters for nature and people. The Nature Conservancy has projects in all fifty states and in thirty countries. The organization's work focuses on protecting ecologically important lands and waters for nature and people. The Nature Conservancy owns the 4,122-acre Port Susan Bay Preserve, which encompasses much of the Stillaguamish River estuary. Port Susan Bay plays an important role in the overall health of Puget Sound as one of the largest remaining relatively undeveloped bays. It is also a critical nursery for marine life. The Nature Conservancy is a 501(c)(3) international nonprofit organization founded in 1951.
• Visit the Nature Conservancy on the web at www.nature.org.

CAMANO WILDLIFE HABITAT PROJECT

Camano Island was the tenth community in the nation certified as a Community Wildlife Habitat by the National Wildlife Federation. Single- and multi-family residences, businesses, schools and demonstration gardens are individually certified to support a community that shares space with wildlife. The project strives to restore wildlife corridors by keeping Camano a wildlife-friendly island. Islanders create, preserve, enhance and restore wildlife habitat by providing food, water, shelter and a place to raise young and by using responsible gardening techniques. The project is sponsored by Friends of Camano Island Parks.
• Visit Camano Wildlife Habitat Project on the web at www. camanowildlifehabitat.org.

NATIONAL WILDLIFE FEDERATION

The National Wildlife Federation is a voice for wildlife, dedicated to protecting wildlife and habitat, as well as inspiring the future generation of conservationists. NWF considers helping wildlife survive the challenges of the twenty-first century, like climate change and habitat loss, is best done by:

> • *working with diverse groups to achieve common conservation goals,*
> • *forming resilient and sustainable solutions to problems facing the environment and wildlife, and*
> • *focusing on the future of conservation, as well as the present, to ensure America's wildlife legacy lives on.*

The organization began certifying Backyard Wildlife Habitats in 1973 and certified Alpine, California, as the first community in 1998.
• Visit National Wildlife Federation on the web at www.nwf.org.

SHORE STEWARDS

Island County Shore Stewards was the first Shore Steward program in Washington State. Shore Stewards began in 2003 as a project of the Island County Marine Resources Committee in collaboration with Washington

State University Beach Watchers of Camano Island. The program helps participants learn better ways of managing their land to preserve critical habitat for fish, wildlife and birds. Shore Stewards was created to help shoreline residents feel more connected to the near-shore ecosystem. By understanding the natural processes at work on the beach, citizens may play a more active, positive role in the preservation of healthy, fish-friendly wildlife habitats.

• Visit Shore Stewards on the web at www.shorestewards.org.

Bibliography

Andrews, John. "Wetland Analysis for Four Springs Lake Preserve." Conservation Futures Application Attachment, Wetlands Evaluation Expert, Snohomish County, 1999.

Baker, Jenny. "RE: Kristoferson Creek Beaver Marsh Proposal." Everett, WA: Snohomish Conservation District, September 23, 2002.

Bakken, Ole, and Roy Hobbs. *Hello from Camano Island.* N.p.: Friends of Cama, 1993.

Beamer, E.M., W.T. Zackey, D. Marks, D. Teel, D. Kuligowski and R. Henderson. "Juvenile Chinook Salmon Rearing in Small Non-Natal Streams Draining into the Whidbey Basin." LaConner, WA: Skagit River System Cooperative, 2013.

Brock, Barbara. "Application for Salmon Recovery Board Funds: Kristoferson Creek Beaver Marsh." *Application Authorization Memorandum.* Camano Island, WA: Friends of Camano Island Parks, August 15, 2002.

———. "Conservation Futures Presentation to Citizen Advisory Board." Camano Island, WA: Friends of Camano Island Parks, May 7, 2003.

———. "Letter of Intent to Salmon Recovery Funding Board." Camano Island, WA: Friends of Camano Island Parks, August 1, 2002.

———. "Welcome to Elger Bay Beaver Marsh." Camano Island, WA: Friends of Camano Island Parks, 2007.

———. "Welcome to Kristoferson Creek Habitat." Camano Island, WA: Friends of Camano Island Parks, 2007.

Buse, Penny Hutchison. *Stuck in the Mud: The History of Warm Beach, Washington.* Snohomish, WA: Snohomish Publishing Company, 2011.

Cama Beach Foundation. Cama Beach Foundation Home Page. September 21, 2013. www.camabeachfoundation.org (accessed October 10, 2013).

"Cama Beach Study." Olympia: Washington State Parks and Recreation Commission, 1995.

"Cama Beach Vision Statement." Olympia: Washington State Parks and Recreation Commission, April 17, 1995.

The Center for Wooden Boats. The Center for Wooden Boats: Cama Beach. cwb.org/locations/cama-beach (accessed October 10, 2013).

Court's Memorandum Decision. 93-2-00278-0. Superior Court of Island County, WA, November 15, 1995.

Dean, John. "For Salmon: Biologists Plan Two Island Acquisitions." *Stanwood/Camano News*, September 10, 2002, 13.

"Determination of Non-Significance." Resources Development Division, Washington State Parks and Recreation Commission, Olympia, Washington, 1996.

Dilorenzo, Carolin Barnum. Inn at Barnum Point. 1996–2004. www.innatbarnumpoint.com (accessed November 30, 2013).

Eisenberg, Tom. "A Summary of FOCIP Involvement at Iverson Spit Preserve." Camano Island, 2014.

English Bay v. Island County. No. 44841. Supreme Court of Washington, September 9, 1977.

Essex, Alice. *The Stanwood Story.* Vols. 1–3. Stanwood, WA: Stanwood/Camano News, 1995–1998.

Friends of Camano Island Parks. "English Boom Historical Waterfront Trail and Park." *Island County Conservation Futures Program: Application for Conservation Futures Funds.* Camano Island, WA: Friends of Camano Island Parks, February 27, 1997.

———. "Four Springs Lake Preserve: An Opportunity to Preserve 50 Acres of Forest, Lake, Wetlands, and Meadow for Future Generations on Camano Island." May 2000.

———. "Kristoferson Creek Beaver Marsh." *Island County Conservation Futures Program: Application for Conservation Futures Funds.* Camano Island, WA: Friends of Camano Island Parks, 2002.

Gressett, Maxine. "The Kristoferson Farm." *Stanwood Area Echoes* (June 2002): 1–4.

Hamalainen, Karen. "Conservation Futures Committee and Island County Commissioners." Camano Island, WA, May 23, 1997.

Hilton, Chris. "Land Trust Protects Critical Heron Habitat." Whidbey Camano Land Trust, February 20, 2009.

Island County Outdoor Recreational Enthusiast; Friends of Camano Island Parks. "Island County Parks: Camano Ridge Preserve Comprehensive Trail Plan." Camano Island, WA: Island County Outdoor Recreational Enthusiast; Friends of Camano Island Parks, 2004.

Kimball, Art, and John Dean. *Camano Island: Life and Times in Island Paradise.* Stanwood, WA: Stanwood/Camano News, 1994.

Kosky, Debra. "FOCIP Meeting Minutes." Friends of Camano Island Parks, October 7, 2002.

Kukuk, Matthew. "Update on Henry Lane Conservation Futures Application." Island County Department of Planning and Community Development, June 9, 2009.

Lewis, Phil. *CARE History for CARE Retreat, 2004.* Camano Island, WA: Camano Action for a Rural Environment, 2004.

Manning, Harvey. *Footsore 3: Walks and Hikes around Puget Sound.* Seattle, WA: Mountaineers, 1981.

Mapes, Lynda. "Deltas Are Prized Spot for Shorebirds." *Seattle Times,* February 10, 2013. seattletimes.com/html/localnews/2020332640_shorebirdsxml.html (accessed November 29, 2013).

McDonald, Cathy. "Walkabout: English Boom Historical Park." *Seattle Times,* October 26, 2006. seattletimes.com/html/outdoors/2003322776_nwwwalkabout26.html (accessed October 13, 2013).

Mowery, John, Judith Mowery and Carol Triplett. "Dry Lake Road Wetland and Trailhead Park." *Island County Conservation Futures Program.* Camano Island, WA: Friends of Camano Island Parks, February 27, 1997.

Mueller, Marge, and Ted Mueller. *North Puget Sound Afoot and Afloat.* Seattle, WA: Mountaineers, 1988.

Nash, Patricia. "A History of Four Springs Lake Preserve on Camano Island." *Island County Conservation Futures Program.* Camano Island, WA: Friends of Camano Island Parks, February 22, 1999.

Northwest Ecological Services. "Iverson Spit Site Management Plan." Bellingham, WA, December 2011.

Opperman, Hal N., PhD. "Island County Conservation Futures Program." Medina, WA, February 18, 1997.

Parsons, Christine. "Camano Island State Park Land Classification and Long-Term Boundaries Environmental Checklist." *Determination of Nonsignificance: State Environmental Policy Act.* Olympia: Washington State Parks and Recreation Commission, October 22, 2013.

Pinkham, David. "Editorial: Lake Preserve, Place of Many Uses, Dream that Could Be Reality." *Stanwood/Camano News*, August 22, 2000, 4.

Pollock, M.M., and G.R. Pess. "The Current and Historical Influence of Beaver (*Castor Canadensis*) on Coho (*Oncorhynchus kisutch*) Smolt Production in the Stillaguamish River Basin." Seattle, WA: 10,000 Year Institute, 1998.

Powell, Pat. E-mail. Greenbank, WA: Whidbey Camano Land Trust, April 17, 2003.

———. "Kristoferson Creek Riparian and Wetland Protection." *Island County Conservation Futures Program*. Langley, WA: Whidbey Camano Land Trust, January 2005.

Powell, Pat, and Pam Pritzl. "Davis Slough Heron Rookery, Camano Island." *Island County Conservation Futures Program*. Langley, WA: Whidbey Camano Land Trust, February 28, 2003.

Prasse, Karen. "Steamers, Ships, and Shorelines." Camano Island, WA: Puget Sound Partnership, September 21, 2013.

Prasse, Karen, and Stanwood Area Historical Society. *Images of America: Camano Island*. Charleston, SC: Arcadia Publishing, 2006.

Pritzl, Pam. "Efforts Intensify to Save Camano Heron Rookery." *Stanwood/Camano News*, April 1, 2003, 15.

Raymond, Steve. "Livingston Bay: Our Latest Save." *Whidbey Camano Land Trust Newsletter*, Winter 2007.

Reardon, Kate. "Blue Herons Losing Camano Landlord." *The Herald*, October 28, 2002, A1, A6.

Reed, Claudia. "Belcher: Sale of DNR Forest Not Inevitable." *Stanwood/Camano News*, September 13, 1995.

———. "Catherine Hedges: Tales of the Old Camano Island." *Stanwood/Camano News*, December 9, 1992.

———. "Islanders Eye English Boom for Scenic Shoreline Walk-In Park." *Stanwood/Camano News*, February 4, 1997.

———. "Islanders Opposing Shopping Center." *Stanwood/Camano News*, October 7, 1997, 15, 24.

Riggs, Tom. "Dry Lake Road Trailhead Park Phase II." Camano Island, WA, February 21, 2007.

Schmidt, Sarah, Dan Pedersen and Stacey Neumiller. *Getting to the Water's Edge on Whidbey and Camano Islands*. Rev. ed. Coupeville: Washington State University Extension–Island County; Island County Marine Resources Committee; WSU Beach Watchers–Island County, 2006.

Seymour, Steve. "RE: Kristoferson Creek." *State of Washington: Department of Fish and Wildlife*. Bellingham, WA: Department of Fish and Wildlife, February 27, 2003.

Sharp, Ginny. "Community Effort to Preserve 50-Acre Natural Ecosystem Unique to Camano Island." Friends of Camano Island Parks, March 29, 2000.

———. "Friends of Camano Island Parks Honors Royce and Rhea Natoli." Camano Island, WA, February 23, 2010.

Sheets, Bill. "Island County, Group Preserve 52 Acres on Camano for Park." *The Herald*, April 17, 2013. www.heraldnet.com/article/20130417/NEWS01/704179936 (accessed November 30, 2013).

Sheldon & Associates, Inc. "Iverson Farm Restoration Feasibility Study: Camano Island, Island County." Seattle, WA: Sheldon & Associates, Inc., October 18, 2001, 38.

Shuman, Howard. "Urgency Mounts to Protect Herons' Home." *Stanwood/Camano News*, July 29, 2003, 14.

Skagit Audubon Society. Skagit Audubon Society—Home. October 2013. www.fidalgo.net/~audubon (accessed October 15, 2013).

South Camano Grange. *Grange Community Service Project—1949.* Camano Island, WA: South Camano Grange, 1949.

Stanton, Robin. Island County, Nature Conservancy Preserve Barnum Point. March 29, 2013. www.nature.org/ourinitiatives/regions/northamerica/unitedstates/washington/newsroom/washington-barnum-point-preserved.xml (accessed November 29, 2013).

———. "Washington: Restoration Underway at Livingston Bay." Stanwood: Nature Conservancy in Washington, September 23, 2012.

Stanwood Area Historical Society. "The Short Life of the Oyster Industry in the Stanwood Camano Area." *Stanwood Area Echoes* (March 2005): 2–3.

———. "South Camano Grange." *Stanwood Area Echoes* (June 2003): 4–5.

Stanwood/Camano News. "50-Acre Preserve on Camano Opens Nov. 6; Public Invited." October 26, 2004, 15–16.

———. "Grocery Store Chain Buys Terry's Corner Acreage for New Island Store." April 19, 1989.

———. "$100,000 Raised So Far for Proposed New Park, Led by Donation of $88,000." April 4, 2000, 13.

Stanwood News. "Building Permit Issued for Camano Mall." May 26, 1976, 1.

———. "Clam Boat Sold; Court Hears Harvesting Case." June 22, 1977, 1, 7.

———. "Clam Dredge Put Up for Sale Here." May 4, 1977.

———. "New Interchange Being Planned at Terry's Corner." September 26, 1973.

Starr, Judy. "Island Shopping Center Slated." *Stanwood News*, March 24, 1976, 1.

Steele, E.N. *The Immigrant Oyster.* Seattle, WA: Pacific Coast Oyster Growers Association, Inc., n.d.

Stone, Deborah. "Camano Island: One of the Northwest's Best-Kept Secrets." May 30, 2005. www.nwnews.com/old/editions/2005/050530/features4.htm (accessed November 30, 2013).

Swanson, James O. "RE: English Boom Island County Park Proposal." Camano Island, WA: Friends of Camano Island Parks, January 27, 1997.

Triplett, Carol. "Camano Island Guided Winter Walk Participants." Camano Island, WA: Friends of Camano Island Parks, March 15, 1999.

———. "Dry Lake Road Wetland and Trailhead Park—Phase 2." *Island County Conservation Futures Program.* Camano Island, WA: Friends of Camano Island Parks, February 21, 2007.

———. "English Boom Historical Waterfront Trail and Park." *Island County Conservation Futures Proposal.* Camano Island, WA: Friends of Camano Island Parks, 1997.

———. "Four Springs Lake Preserve." *Island County Conservation Futures Funds.* Camano Island, WA: Friends of Camano Island Parks, February 22, 1999.

———. *Four Springs Lake Preserve History of Acquisition.* Friends of Camano Island Parks, 2001.

———. Letter to Mrs. Merle Morris. Camano Island, WA, January 16, 1997.

———. "Morris Property: English Boom Historical Park and Trailhead." Camano Island, WA: Friends of Camano Island Parks, 1997.

———. "Mr. Michael Brown, Construction Manager." Camano Island, WA: Friends of Camano Island Parks, December 16, 1998.

———. "Trail Notes Regarding: Carp Lake DNR Land to Island County Cross Island Forest Preserve." Camano Island, WA, 2003.

———. *Walking the Camano Island Trails.* Camano Island, WA: Friends of Camano Island Parks, 2012.

Washington Department of Fish and Wildlife. "Wildlife Program: Week of August 5–11, 2013." August 5, 2013.

Washington Parks and Recreation Commission—Planning Team. *Camano Island State Park: Stage Four—Final Recommendation Report to the Parks and Recreation Commission.* Classification and Management Plan, Washington Parks and Recreation Commission. Olympia: Washington Parks and Recreation Commission, 2013, 37.

Washington State Department of Natural Resources. "Priority 23: Elger Bay." *1997–1999 Trust Land Transfer Program Summary.* Olympia: Washington State Department of Natural Resources, September 1996, 49.

———. *Trust Land Transfer Program 2001–2003.* Department of Natural Resources, Washington State. Olympia: Department of Natural Resources, 2000.

Washington State Parks. Cama Beach State Park Home Page. parks.wa.gov/camabeach/default.aspx (accessed October 10, 2013).

Water Conservation Commission. "Salmon Habitat Limiting Factors Final Report." *Water Resource Inventory Area 5 Stillaguamish Watershed.* Olympia: Washington State Water Conservation Commission, July 1999.

Wendel, Peggy. "Camano Briefed on DNR Land Rules." *The Herald,* September 11, 1995, 2B.

Whalen, Nathan. "County Approves Heron Rookery, Utsalady Land." *Stanwood/Camano News,* July 29, 2003, 14.

Wheeler, Jeff, and Tina Dinzl-Pederson. "Story of the Washington State Park System." Camano Island, WA: WSU Beach Watchers–Camano, September 25, 2013.

Whidbey Camano Land Trust. "Help Save a Vital Puget Sound Heronry." *Invest in a Different Kind of Nest Egg…Help Preserve the Home of the Davis Slough Herons.* Langley, WA: Whidbey Camano Land Trust and the Friends of Camano Island Parks, July 15, 2003, 4.

———. "Kristoferson Creek Landowner Spotlight." *Whidbey Camano Land Trust Newsletter* (Winter 2008): 3.

———. Livingston Bay. www.wclt.org/protected-areas/livingston-bay/livingston-bay (accessed June 2013).

———. "Permanent Access to Lower Kristoferson Creek Assured in Land Sale." Langley, WA: Whidbey Camano Land Trust, February 1, 2007.

———. "Protecting Camano's Salmon and Wetlands." *Whidbey Camano Land Trust Newsletter* (Winter 2008): 3.

———. Success Stories. July 2013. www.wclt.org/what-we-do/success-stories/success-stories-2 (accessed October 11, 2013).

White, Richard. *Land Use, Environment, and Social Change: The Shaping of Island County, Washington.* Seattle: University of Washington Press, 1980.

Worthington, Gary. *Cama Beach—A Guide and a History: How a Unique State Park Was Created from a Family Fishing Resort and a Native American Camping Site.* Olympia, WA: TimeBridges Publishers, 2008.

Index

About the Author

Val Schroeder moved to Camano Island in 1994 before the acquisition of most of the island's parks and preserves. To help implement the 1995 Island County Non-Motorized Trails Plan, she joined Friends of Camano Island Parks' trails committee. In 2002, she began the Camano Wildlife Habitat Project. After certifying Camano Island as a Community Wildlife Habitat, the National Wildlife Federation recognized Schroeder as the Volunteer of the Year in 2006. Besides her volunteer work on the island, Schroeder teaches high school English, including nature literature and creative writing. She also writes feature and news articles for local publications about Friends of Camano Island Parks and the Camano Wildlife Habitat Project. Schroeder kayaks, bikes and strolls the beach to English Boom whenever she has the chance.

The author on another Camano Island beach walk. *Dave Baumchen.*